IMAGES
of England

FOLKESTONE

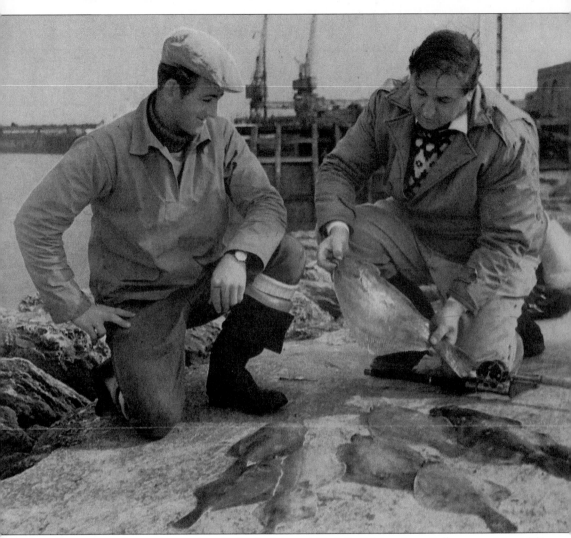

Some magnificent plaice taken by Leslie Moncrieff while fishing from Folkestone, May 1964. With him is Alan Taylor, skipper of the fishing boat *Good Heart*. The fishing magazine *Creel* had commissioned Leslie Moncrieff to write an article about plaice fishing on the mussel beds off Folkestone. Mr Moncrieff was the champion rod caster of Great Britain, a well known figure in angling circles.

IMAGES
of England

FOLKESTONE

Compiled by
Alan F. Taylor

TEMPUS

First published 1998
Copyright © Author names, 1998

Tempus Publishing Limited
The Mill, Brimscombe Port,
Stroud, Gloucestershire, GL5 2QG

ISBN 0 7524 1180 2

Typesetting and origination by
Tempus Publishing Limited
Printed in Great Britain by
Bailey Print, Dursley, Gloucestershire

I dedicate this book to my wife, Eileen, for her patience and understanding over the past few months, and to my son, Andrew, for his help and support.

Contents

Acknowledgements 6

Introduction 7

1. 1820s Watercolours 9

2. Streets and Trade 19

3. Around the Harbour 53

4. Events 75

5. Transport 99

6. More Glimpses of Bygone Folkestone 115

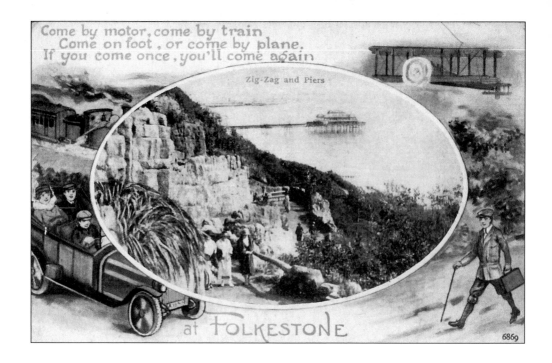

Acknowledgements

This publication has been compiled entirely from the collections of Alan Taylor and the late C.P. Davies. I am indebted to those people who, over the years, have loaned me photographs to copy, thus helping to build my collection. First and foremost, I would like to thank Tempus Publishing for inviting me to compile this book on Folkestone. For my part, the compilation has largely been made possible by people allowing me to copy their photographs. My contact with many people has been through book signings for my previous publications, giving illustrated talks on old Folkestone to various organizations and photograph exhibitions put on by the Folkestone and District Local History Society, of which I am Secretary.

I should like to offer sincere thanks to all the following people: H.W. Baldock, Anne Beaney, Mrs Beckingham, Ray Clare, Jack Darby, Jakki Elvy (née Burch), John Gale, Keith Godden, Gwen Gould, Joe Harman, Edward Hart, Peter Hooper, Bill Lester, Maurice Lester, Mr H. Long, Emily May (née Fagg), John McLaren, Jesse Milton, Michael Milton, Mrs R. Milton (née Avery), Mrs Pegden, Chris Phillips, Mrs Rawlings, Jean Robey, Ray Saunders, Malcolm Stokes, Grace Tomlinson (née May) and Mrs J. Walsh.

I'VE ONLY ONE DONKEY IN THIS VIEW
IF YOU'D BEEN HERE I'D HAVE HAD TWO.

The Upper Leas

at FOLKESTONE

273

Introduction

The first section consists of images which are unique and pre-date photography. They come from a collection of watercolours painted in the 1820s by Joshua Marsh. Mr Marsh was a native of Folkestone, who lived and worked in London as a portrait painter. Also included is a section on the fishing industry which is always very popular as there are still many people in and around Folkestone whose ancestors were, in one way or another, connected with the industry.

There are three main factors which contributed to the start of Folkestone's prosperity. The first and most important was the coming of the railway direct from London, which opened on 28 June 1843. The second was the takeover by the South Eastern Railway Company of the Harbour and the building of the branch line to the Harbour in 1844. At first it was mainly used to bring sea-borne coal up to the coke ovens at the junction station. But when the swing-bridge was built, passengers were able to alight at the Harbour, and train services could be tied in with boat sailings, allowing comparatively swift travel to the continent. This led to greater trade for Folkestone and development of the Harbour.

The third factor was the decision by the Earl of Radnor to develop Folkestone. Sidney Smirke from London was to be the architect. At first it was thought the town would expand eastwards, but it quickly became clear that demand was towards the west. Wide, tree-lined streets were laid out, squares planned and, on land which had been formerly used for grazing, the Leas was created. The key buildings constructed during this period were the Pavilion Hotel in 1843, the West Cliff Hotel in 1856 and the new Town Hall in 1861. In 1850 Christ Church, Sandgate Road, had been consecrated and within the next fifty years five further churches, Holy Trinity, Sandgate Road, St John's, Church Road, St Michael's, Dover Road, St Peter's, The Durlocks,

and St Saviour's, Canterbury Road, were also built, as well as nonconformist and Roman Catholic places of worship. The Bathing Establishment was erected in 1869 and the National Arts Treasures Exhibition, Bouverie Road West, opened on 15 May 1866, later becoming the Pleasure Gardens Theatre in 1888. The Museum opened on 8 October 1870, the Radnor Club opened on 30 May 1874, the Leas Lifts on 21 September 1885, Radnor Park on 9 June 1886, the Victoria Pier on 21 July 1888, the Switchback Railway on 17 August 1888, the Marine Gardens on 29 June 1892 and the Sandgate Hill Lift on 20 February 1893. The Marine Bandstand was erected in 1895, the Leas Shelter in 1894 and the Metropole Hotel in 1897, while the Leas Pavilion Theatre opened on 28 June 1902, the Grand Hotel opened as the Grand Mansions on 12 September 1903 and the Metropole Lift opened on 31 March 1904. All these buildings were opened to attract and accommodate visitors to the town.

In the Edwardian era, Folkestone reached its fashionable peak, with bands playing on the Leas and the wealthy with their servants, carriages and bathchairs 'taking the air' there. It was the place to be seen, where the undesirables were kept away by Lord Radnor's policemen. The Savoy Cinema on Grace Hill, formerly the Electric Theatre, opened on 3 May 1910, The Queen's Cinema, Tontine Street opened in June 1912, the Playhouse Cinema, Guildhall Street, opened on 14 August 1912 and the Central Cinema in George Lane opened in 1912. But alas, all this came to an end with the outbreak of the First World War in 1914. Soon after their country had been overrun, the first of 65,000 Belgian refugees began to arrive, often possessing nothing but the clothes in which they stood. They were cared for by the Folkestone townspeople and the Belgian Committee for Refugees. From March 1915 onwards, Folkestone also became the main embarkation point for soldiers on their way to the Continent. Tens of thousands marched down the slope road (now called the Road of Remembrance) to the Harbour. Thousands of them returned wounded and hospitals, convalescent homes and rest camps were soon set up around the town. Folkestone suffered an air raid on 25 May 1917, when a bomb fell on Tontine Street, causing sixty-one deaths and ninety-six injuries.

At the end of the war in 1918 it was realized that if Folkestone was to survive as a holiday resort, it would have to attract the working class people, not just the rich. 'Floral Folkestone' was created and attractive flower-beds were laid out in Sandgate Road, The Leas and Radnor Park. Smaller hotels and boarding houses opened up and many households with one or more bedrooms to spare took in holidaymakers for bed and breakfast. More attractions were built. The Leas Cliff Hall was opened on 13 July 1927 to replace the smaller Leas Shelter. The Marine Gardens Pavilion opened on 17 March 1926, the East Cliff Pavilion opened in 1934, the Astoria Cinema opened on 20 April 1935, then becoming the Odeon in 1937, and the open air swimming pool in the Marine Gardens was opened on 11 July 1936. During the Second World War, when 35,000 people were evacuated, there were seventy-seven air raids and six V-1s fell on the town. Since the Second World War, Folkestone has never recovered as a holiday resort and it has seen a decline in the cross-Channel shipping trade since the opening of the Channel Tunnel.

A.F.T.
Folkestone, March 1998

One
1820s Watercolours

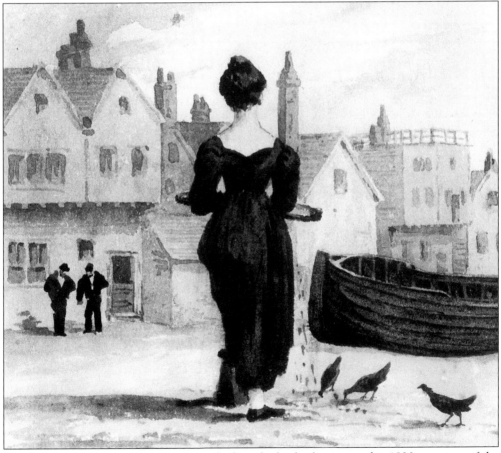

The lady in the elegant Georgian dress, feeding the birds, dominates this 1820s painting of the Stade. The building on the right with the railing round it is a sail maker's loft, while the other buildings are inns, fishermen's houses and stores.

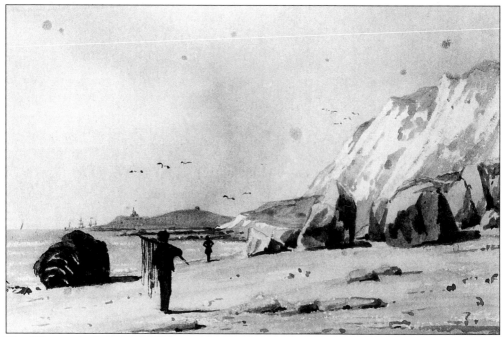

The Warren, looking towards the Harbour, 1820s. In the foreground can be seen a fisherman walking home after gathering his fishing nets. It is interesting to note how far the headland at East Cliff protrudes out to sea.

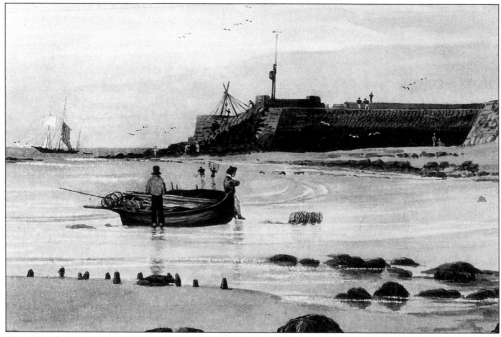

The South Pier, Harbour mouth and East Head, 1820s. The Harbour mouth is to the right of the picture by the two people. In the foreground are two lobster fishermen with their boat and lobster creels, waiting for the tide to come in. Over their boat can be seen two men, fishing for shrimps.

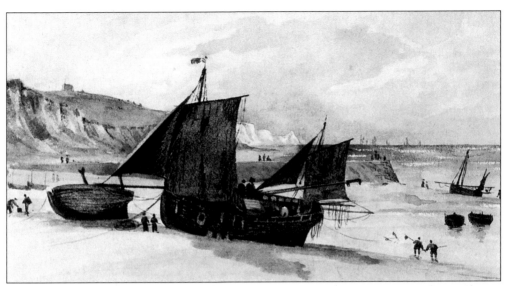

The Outer Harbour at low tide, 1820s. The Harbour, built in 1809, consisted of the South Pier and East Head. Due to the drift of sand and shingle from the south west, the Harbour mouth constantly silted up, as illustrated in this painting. By 1842 it was so clogged up that only fishing boats could use the Harbour; the water was too shallow for the collier brigs to enter. Because it continually had to clear the entrance, and because of the lack of revenue from the collier brigs, the Harbour Company, which had been set up in 1807, went bankrupt. The South Eastern Railway Company bought the Harbour for £18,000 in 1843. A groyne was built in a south westerly direction from the end of the South Pier. This stopped the Harbour mouth silting up and subsequently consolidated the land where the Harbour Station and Custom House were built.

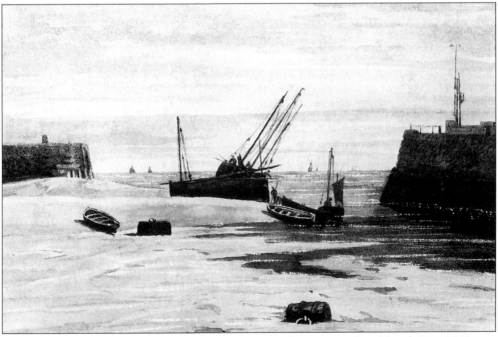

The Harbour mouth, showing the sand bank between the East Head and South Pier, 1820s.

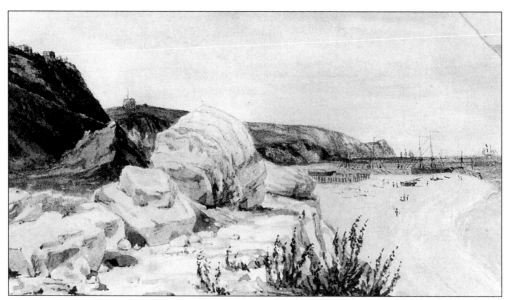

The Harbour wall, South Pier, 1820s. In the foreground, the sandstone rocks are a fine example of those used to build the Harbour. Beyond the Harbour wall can be seen the masts of collier brigs, while to the left of the painting is Martello Tower No. 3.

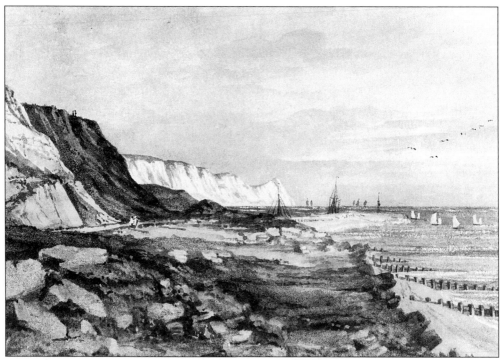

The West Cliff and Under Cliff, 1820s. In the middle distance can be seen the shingle building up behind the South Pier and the masts of the collier brigs and fishing boats making their way towards the Harbour.

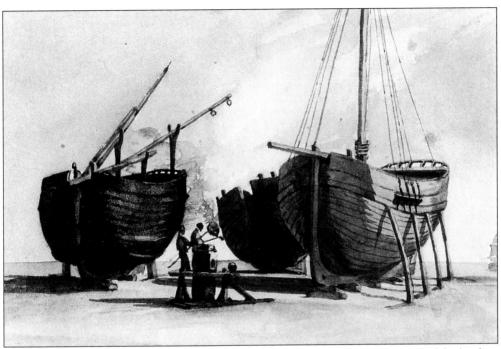

Three fishing luggers on the beach, 1820s. In the centre is a wooden capstan, used for hauling the boats up the beach. Two fishermen can be seen drying and tarring the centre boat.

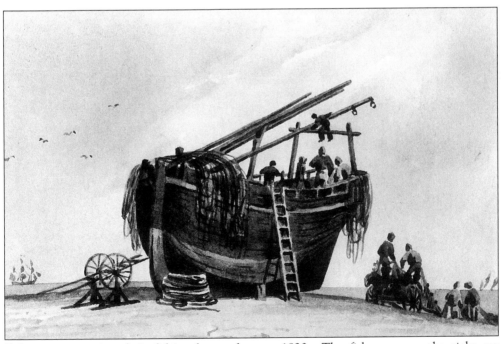

Fishermen preparing their fishing lugger for sea, 1820s. The fishermen on the right are overhauling their fishing nets.

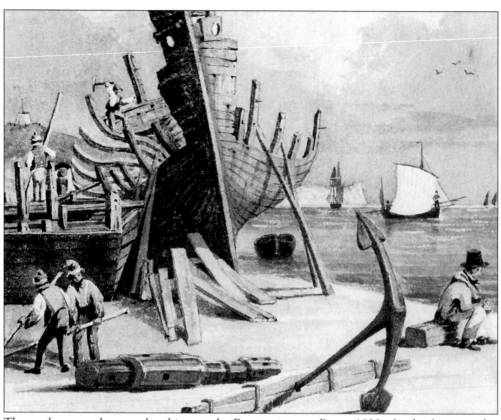

The workers seen here are breaking up the Revenue cutter *Rover*, 1820s. In the foreground is the remains of a capstan and an anchor with a wooden stock.

Fishermen standing in the Harbour at low tide, 1820s.

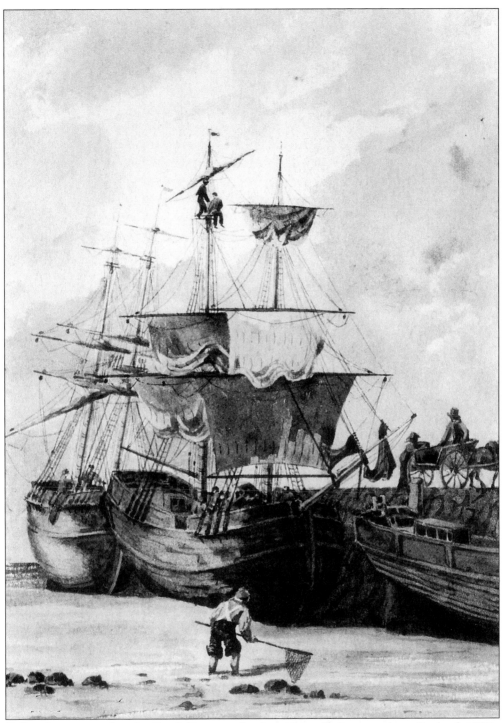

Collier brigs moored at the South Pier to unload coal brought from northern England, 1820s. Note the two men on the mast and the man in the foreground who is fishing for prawns.

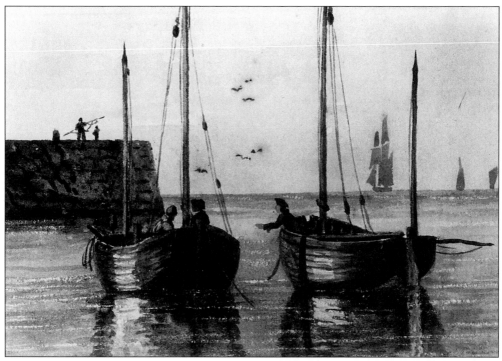

Two clinker-built fishing boats anchored in the Harbour, 1820s.

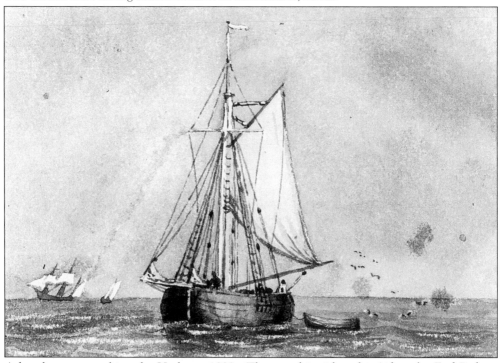

A hoy boat approaching the Harbour, 1820s. The vessel is either the *Aid* or the *Earl Radnor*, both of which ran from Griffins Wharf, Tooley Street, London. They took turns calling at Folkestone every seven days. The masters were William and Jacob Spicer, of Folkestone.

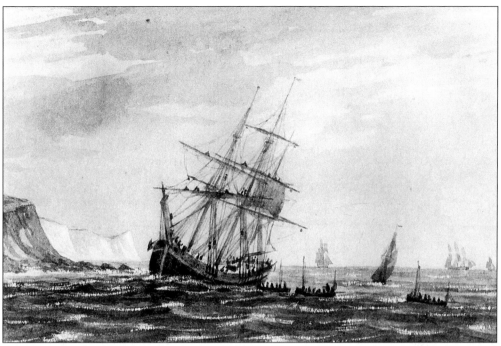

A square-rigged sailing ship, the *American*, 1820s. The *American* is ashore at Copt Point and three small fishing boats are going to her assistance.

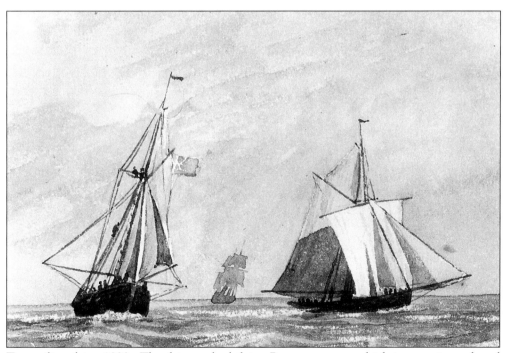

Two sailing ships, 1820s. The ship on the left is a Revenue cutter, which is preparing to board the other vessel to look for contraband.

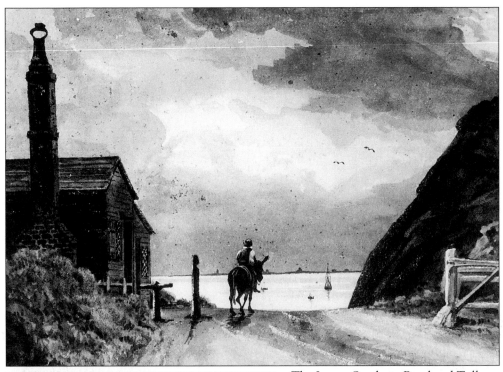

The Lower Sandgate Road and Toll House, 1820s. This Toll House was later demolished to build the present one. At the end of the road can be seen Hythe Bay and Dungeness.

Mill Bay, from the Old High Street, 1820s. The buildings in this watercolour are still there today. Note how rural the rest of Mill Bay is!

Two
Streets and Trade

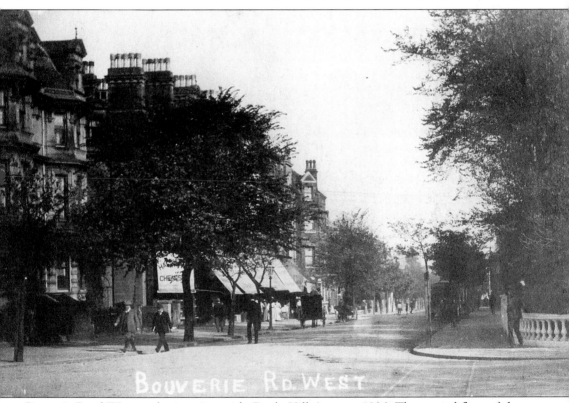

Bouverie Road West at the junction with Castle Hill Avenue, 1906. The ground floor of the houses on the extreme left became a branch of the National Provincial Bank. The chemist's shop, Hall and King's, can just be seen through the trees; they are still in business at the same premises. The wall on the opposite side of the road belongs to the West Cliff Hotel, later known as the Majestic Hotel.

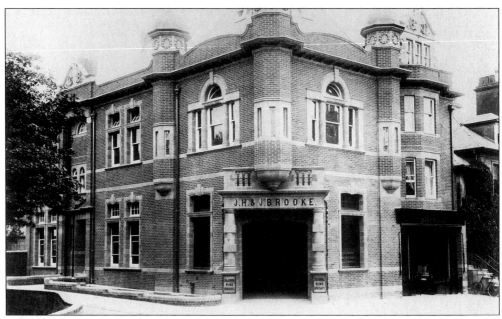

J.H. & J. Brookes, the wine merchants at 134 Sandgate Road, on the corner of Manor Road. The building was built for Brookes by the builder's firm of Charles Jenner and designed by Andrew Bromley. The branch opened in 1903 and closed in 1968. The premises are now occupied by the Royal Bank of Scotland.

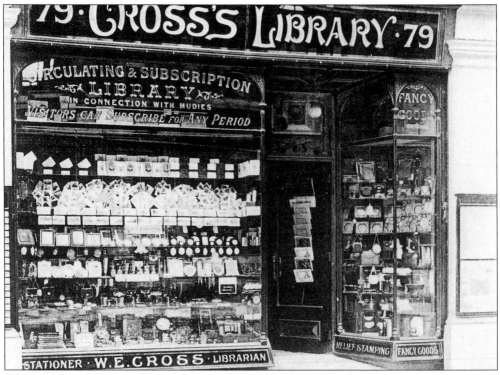

William Edward Cross established his circulating library, stationer's and fancy goods business at 79 Sandgate Road in 1899. The business moved to 119 Sandgate Road in 1986.

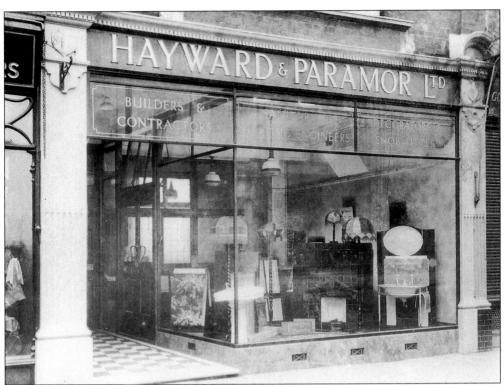

Hayward and Paramor, builders and contractors, 82 Sandgate Road. Hayward and Paramor conducted their business from these premises from 1930 to 1947. The premises are now occupied by Friday-AD.

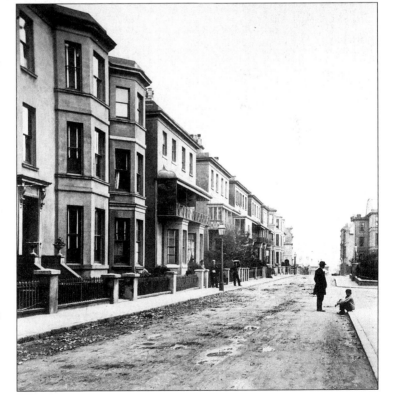

Bouverie Square, c. 1870. Note that the road has not yet been built and also the lack of traffic. Compare this picture with the one overleaf.

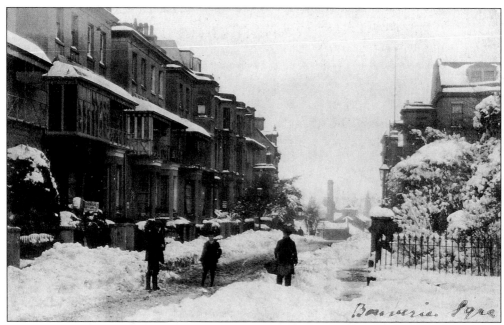

Bouverie Square, during the winter of 1909. The buildings on the left were demolished in 1972 to make way for road-widening. The tall chimney in the distance belongs to the Gun Brewery.

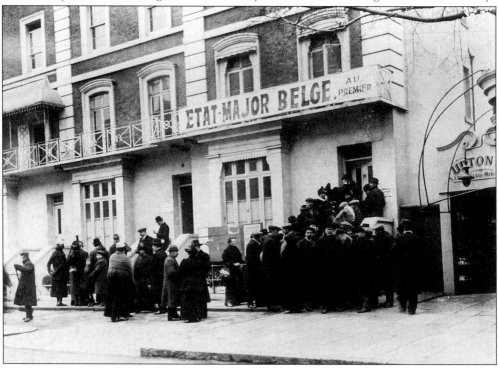

This photograph shows three houses from a row of seven in Sandgate Road which Messrs Bobby and Co. generously placed at the disposal of the Belgians for official purposes during the First World War. The houses were demolished after the war in order to make room for the construction of Bobby's department store.

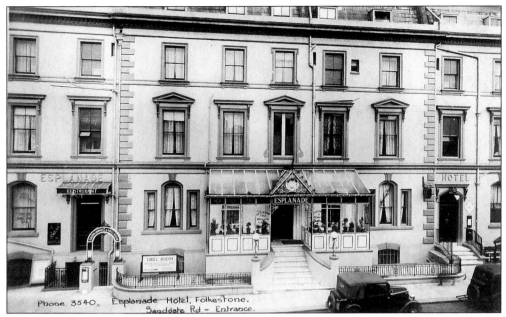

The Esplanade Hotel, formerly Bates Hotel, Sandgate Road. The business was started by Walter Henry Bates in 1859 and taken over by W. Rosenz in 1919, when the name was change to 'Esplanade'. The Esplanade was sold for development and demolished in 1972.

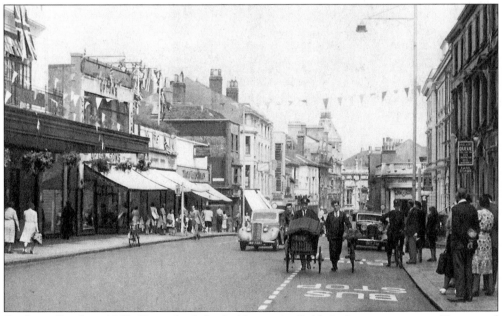

Sandgate Road, c. 1950. From the left, the shops are: Bobby's department store; Upton and Sons' high-class china, glass, toy and stationery dealers; McIlroy's of Kent, drapers; and Timothy White and Taylor's Ltd, chemists.

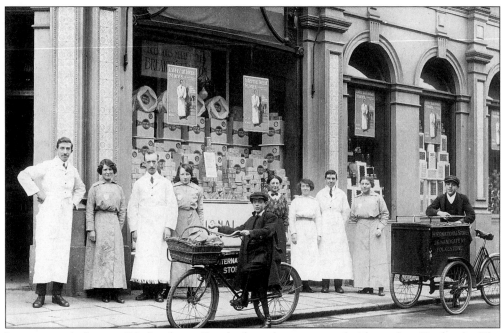

International Stores, 26 Sandgate Road, (on the corner of Alexandra Gardens). The International traded at these premises from 1908 to 1927.

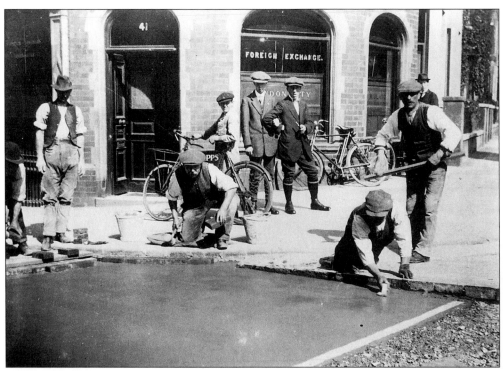

Sandgate Road, opposite the Midland Bank, *c.* 1920. Council workmen are seen here laying wooden blocks on the road, a practice which continued until 1930.

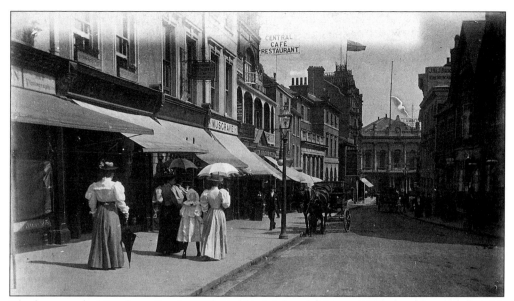

The lower end of Sandgate Road, 1896. On the left hand side are: J.Weston, photographer; H. Pope, china and glass dealers; I. Gironimo, pastry cook; J. Musgrave, draper; H. Sanders, hosiers and hatters; and, at the Central Café, Caro Mastrani, pastry cook.

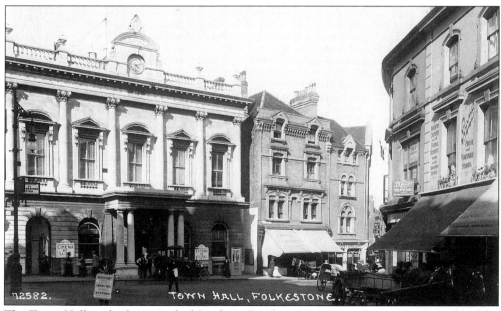

The Town Hall at the lower end of Sandgate Road, c. 1910. Note the signs either side of the porch advertising a 'Cinema De Luxe': the Town Hall continued to show films for a number of years after purpose-built cinemas were operating.

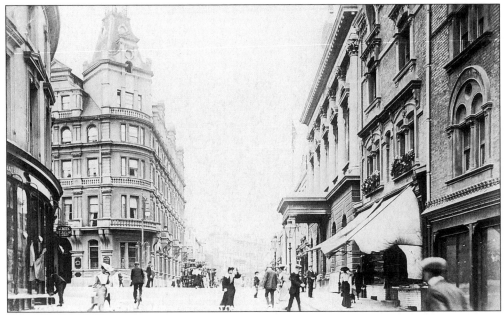

Guildhall Street at the junction with Sandgate Road, looking from Rendezvous Street, c. 1912. The tall building on the left, at the junction with Sandgate Road, is the Queens Hotel. The Queens Hotel was built on part of the Kings Arms site in 1885, at a cost of £30,000.

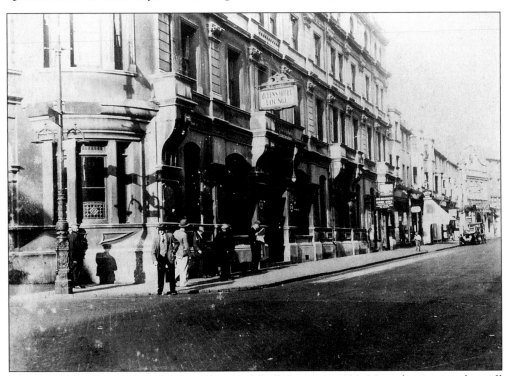

The wall of the Queens Hotel, situated in Guildhall Street, c. 1920. Note the sign on the wall advertising the Lounge Bar. The Queens Hotel was demolished in 1963. In the far distance beyond the car is the Playhouse cinema.

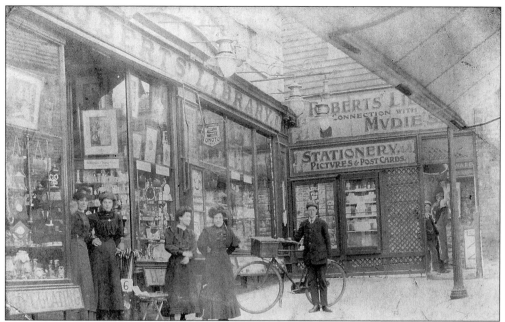

R.Y. Roberts' library, stationery and fancy stores, 11-13 George Lane. Mr Roberts traded from these premises from 1904 to 1911. The buildings were demolished to build the Central Cinema, which opened in 1912.

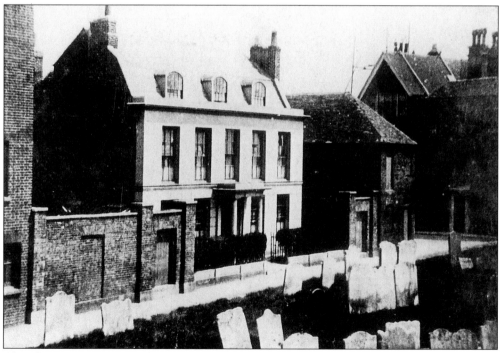

Church Street, 1890s. On the extreme right is Priory House, on The Bayle. All the rest of the buildings were demolished to build St Eanswythe's School, whose foundation stone was laid on 18 April 1901, and the Woodward Hall.

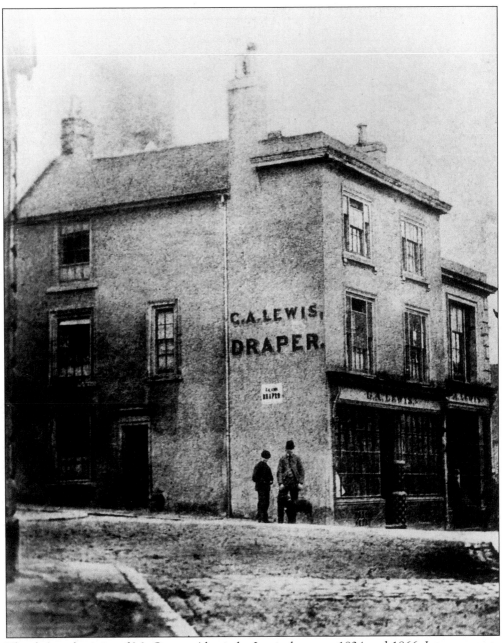

The drapery business of Mr George Alexander Lewis, between 1834 and 1866. Improvements were made to the building in 1867 and eventually the business became known as 'Lewis and Hyland'.

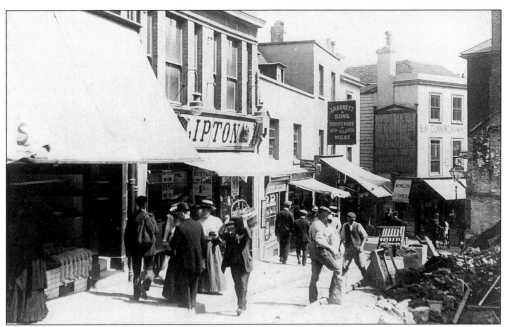

The top end of the High Street, 1909. On the left hand side are: Francis Hedges, fishmonger; Lipton's Ltd, provision dealers; H.C. Smithson, corn and flour dealer; James Gomer, confectioner; J. Harnett, butcher; Savage and Duke, greengrocer; and The World Stores. The pile of rubble on the right is the remains of Mr George Mence Smith's grocery, oil and hardware shop after a fire on 26 April 1909.

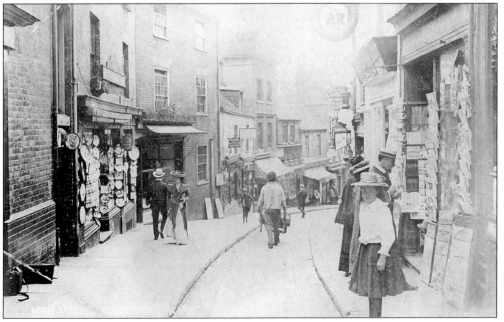

The High Street, following on from the previous picture, 1910. On the left hand side are: the Earl Grey Inn; Mrs Johnson, art dealer; H.J. Camburn, butcher; Charles Ostler, ironmonger; Henry Webber, baker; Salmon and Gluckstein Ltd, tobacconist; and G. Karmy, the Armenian Bazaar.

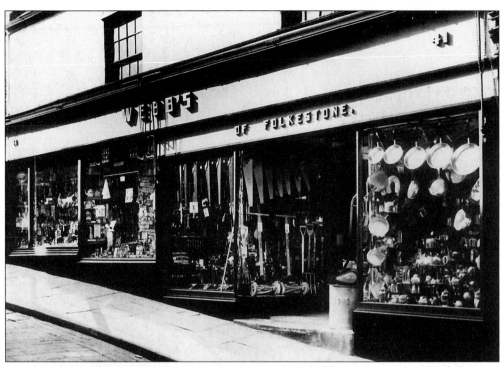

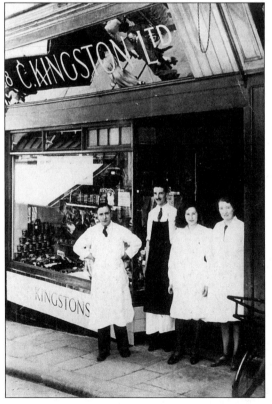

J.H. Webb, ironmonger, 41 High Street. Mr Webb was in business at these premises from 1926 to 1969. The shop is now occupied by a tea room and religious bookshop known as 'The Well'.

C. Kingston Ltd, butchers, at 18 High Street, 4 June 1949. The staff from left to right are: Mr Duncan, Bert Ellender, Gwen Gould and Lilian Court. Mr Kingston traded at these premises from 1938 to 1968.

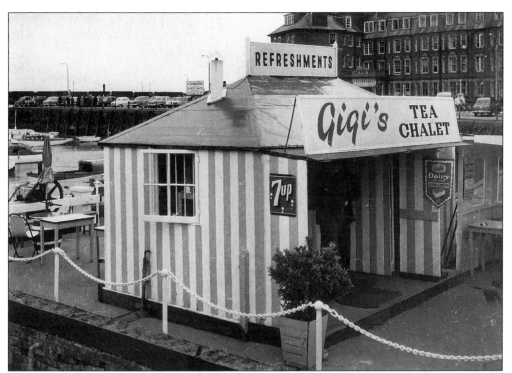

Gigi's Tea Chalet, Inner Harbour, 1961. At this period Gigi's was owned by Mr George Ball. In the following year the building was replaced with a larger one.

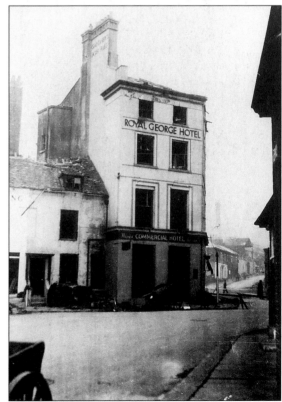

The Royal George, 18 Beach Street. The Royal George was damaged by a parachute mine on 18 November 1940. The two upper floors were demolished because they were badly damaged, but the George continued trading.

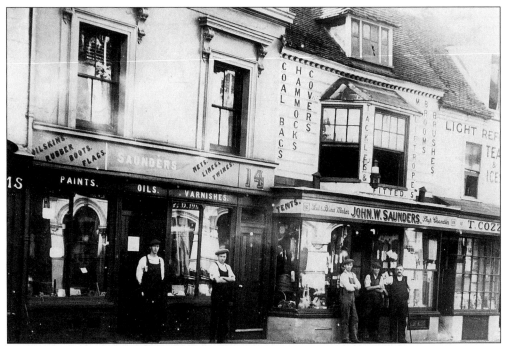

The business of John Saunders and Sons, ships' chandlers, 12-14 Beach Street. Mr Saunders established his business in 1895. The premises were damaged by a parachute mine on 18 November 1940, after which he moved to 20-22 Tontine Street.

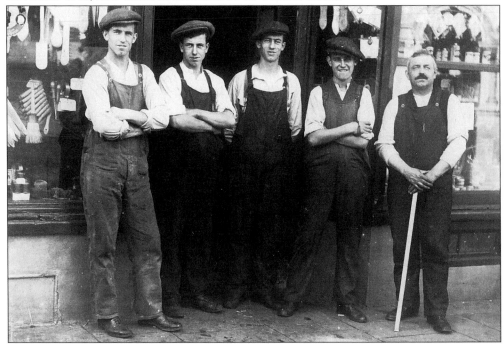

The staff of John Saunders and Sons, ships' chandlers. They are from left to right: John Fagg, Jack, Will and Ernie Saunders, and their father John, who is holding a 'yard stick' used for measuring.

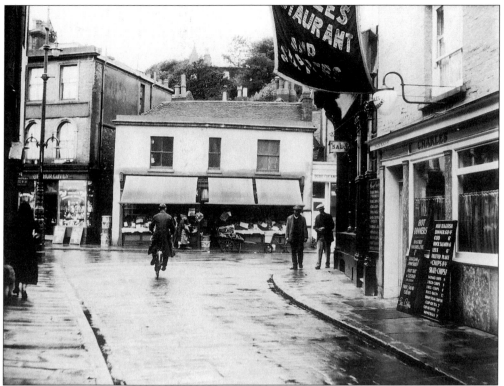

Beach Street at the junction with Harbour Street, *c.* 1925. The shop with the blinds down is 20 Harbour Street, which belonged to James William Mills, fruiterer. Mr Mills occupied these premises from 1901 to 18 November 1940 when the premises were damaged by a parachute mine. On the right is Charles Pinero's restaurant at 24-26 Beach Street.

Harbour Street at the junction with Beach Street, *c.* 1925. On the left corner is the Alexandra Hotel followed by Charles Pinero's restaurant. Mr Pinero occupied these premises from 1923 to 18 November 1940 when all the properties in this picture were damaged by a parachute mine.

The east end of the Stade, 11 June 1912. The black, weather-boarded building became the workshop of Frank Warman, shipwright. All these buildings were demolished in 1934.

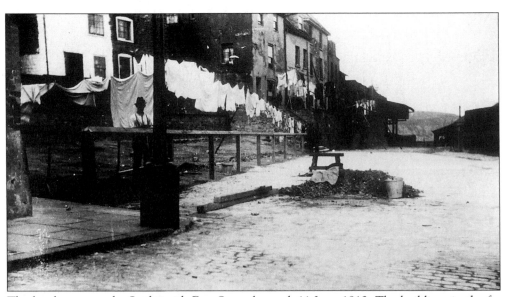

The last houses on the Stade, with East Street beyond, 11 June 1912. The buildings in the far distance are the workshops of the South Eastern and Chatham Railway Company.

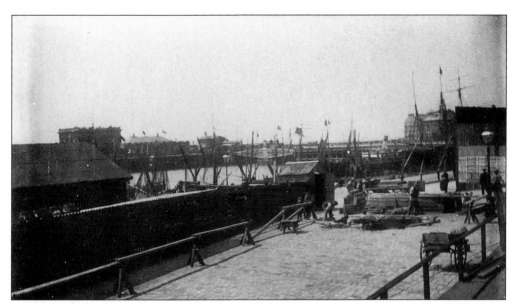

The Stade looking west, 11 June 1912. Road workers can be seen repairing the road – they are laying granite sets. Part of the South Eastern and Chatham Railway Company's workshops are on the left.

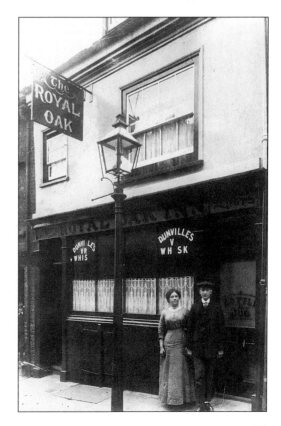

The Royal Oak Inn, 19 North Street, 18 March 1912. The lady in the picture is Mrs Bessie Collar with her son William Henry; the photograph was taken for William's baptism. Mr Collar was landlord from 1902 to 1914, after which he moved to the Red Cow public house. The Royal Oak was damaged during the Second World War, the licence was transferred to the Central Hotel (Park Hotel) in 1949, and the premises were demolished around 1952.

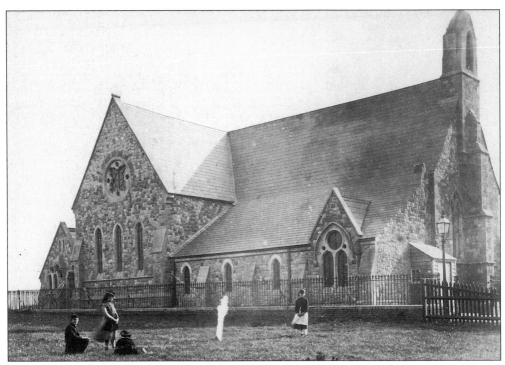

St Peter's church, The Durlocks. The foundation stone at St Peter's was laid in May 1862 and the Church opened on 9 September of that year. The photograph was taken before the extension of 1870.

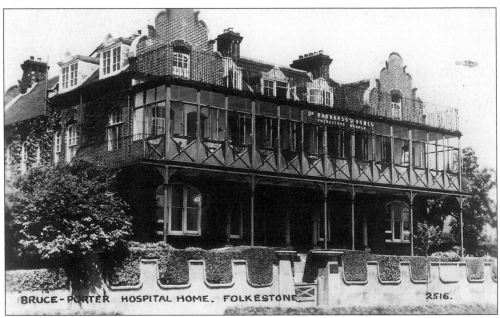

Bruce-Porter Hospital home (Dr Barnardo's), 9-11 Wear Bay Crescent, on the corner of Segrave Road. The home opened in 1920 and remained until 1964. This is now the site of St Clement's Court.

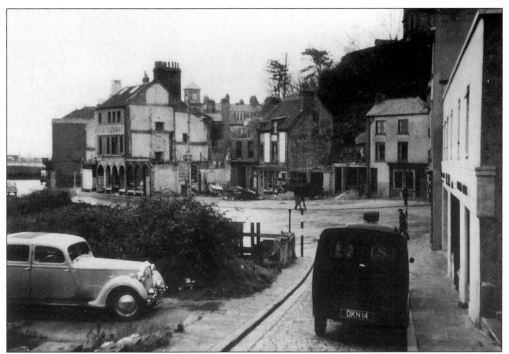

Harbour Street and South Street from Dover Street, 1952. The remaining building facing the camera in Harbour Street is a restaurant owned by Mr O'Donovan, while behind, in South Street, demolition work has just started.

Mr J.T. Sams' wine and spirit merchants, 1-3 Dover Street (now Harbour Way), 1952. This building has just been renovated and turned into the bottling store.

The buildings in this area, covering Beach Street, Seagate Street, Dover Street, Saffron's Place and Little Fenchurch Street have been cleared away after being destroyed by the parachute mine on 18 November 1940 and by shells on 9 November 1942.

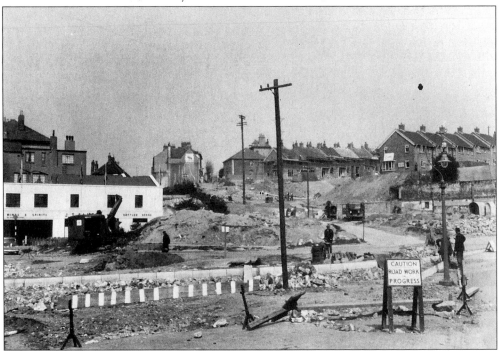

Compare this 1954 picture with the one above. New roads are being laid out and new houses constructed in Dover Street (Harbour Way). Just to the right of Sams' bottling store can be seen the George III public house.

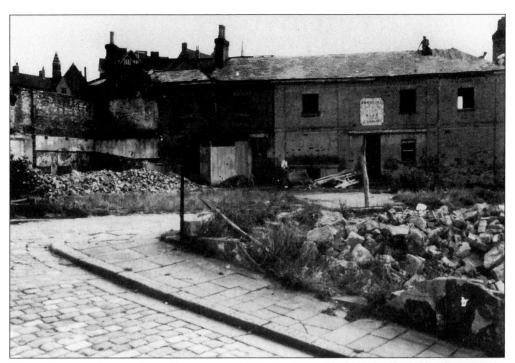

Dover Street at the junction with Seagate Street (all now called Harbour Way), 1952. Demolition work has just started on the Pavilion Shades public house. The picture shows the back of the Pavilion Shades; the front was in The Tram Road. The last landlord was Edward Bishop. The spirit licence was transferred to the Honest Lawyer on 11 February 1959.

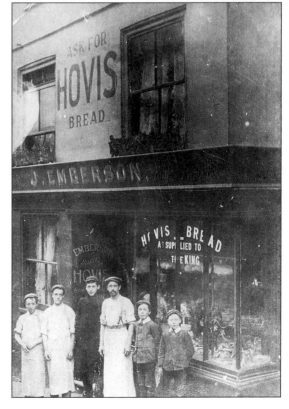

James Emberson's bakery, 5 Dover Street, c. 1910. Among the group of people are George Burvill (baker) and, to his right, Mr Emberson's two sons. Mr Emberson conducted his business at these premises from 1896 until 9 November 1942, when the shop was destroyed by shells, at which time he moved to St John's Street.

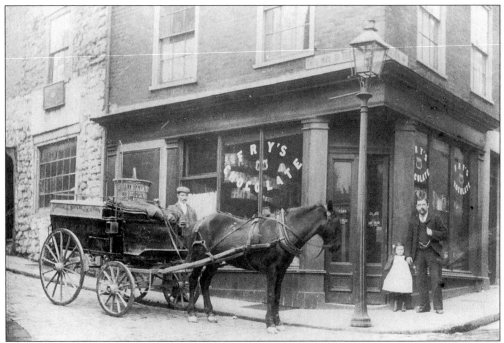

Mr C. Morgan's general shop, at the corner of Little Fenchurch Street and Dover Street, c. 1903. Mr Morgan is seen here with his daughter, May Gladys, who was born on 17 May 1900. Mr Morgan traded at these premises until 1928, when they were taken over by Mr H.J. Knott.

The Primitive Methodist Church, at the corner of Dover Street and Radnor Bridge Road from 1878/82 to 1933. The premises became known as the 'Gordon Club' in 1934 and was the headquarters of the Boys' Brigade. The building was demolished soon after the Second World War.

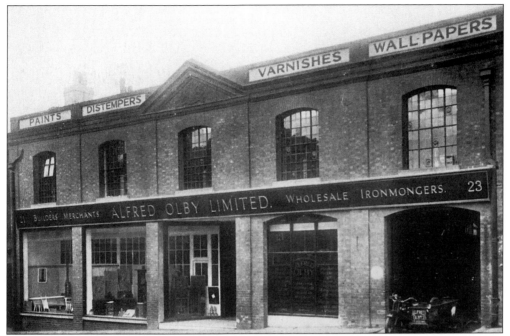

Alfred Olby's wholesale ironmongers at 21-23 Dover Road, formerly Ramell's the coachbuilders. Olby's were at these premises from 1926 to about 1980 when they were taken over by Graham Ford. The site is now occupied by the new Health Centre.

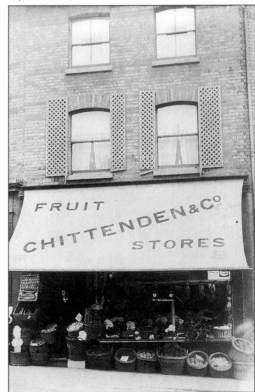

A. Chittenden and Co., the greengrocers, 40 Dover Road. Mr Chittenden traded at these premises from 1910 to 1915.

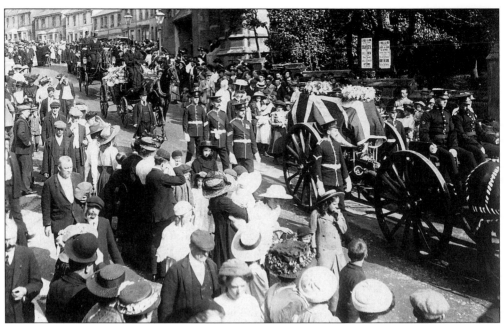

A large crowd has gathered to watch this military funeral make its way down Dover Road, *c.* 1908. Note the gun carriage carrying the coffin. The procession is pictured opposite St Michael's church.

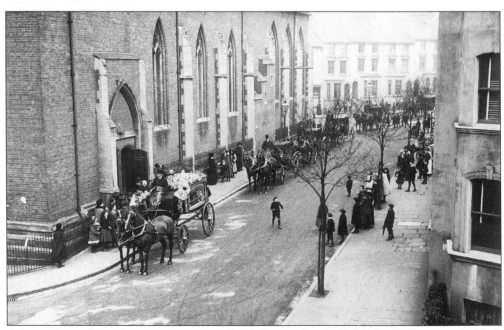

A horse-drawn funeral cortège arriving at St Michael's church, St Michael's Street, *c.* 1908. It appears to be quite a large funeral, as six horse-drawn vehicles can be seen. Note that the first one carrying the coffin has glass sides.

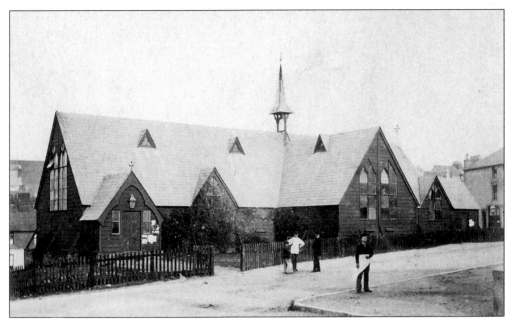

St Michael's temporary wooden church was opened on 11 July 1865 and it was known as the 'Red Barn'. The church was in Dover Road at the junction with St Michael's Street. This view was taken from St Michael's Street. There was an alleged plot to burn the church down on 5 November 1865. This wooden building was replace by a red brick church, designed by F. Bodley, which opened in 1874.

Mr C. B. Packer's ironmonger's shop, 95 Dover Road. Mr Packer was in business at these premises from 1902 to sometime between 1949 and 1952. Standing in the doorway is Bill Orchard, an employee.

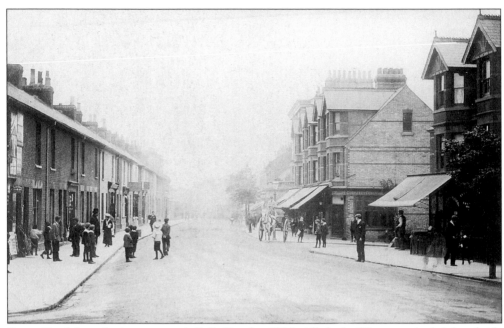

Dover Road from the junction with Folly Road *c*. 1908. All the buildings on the left hand side as far as the first lamp post were destroyed by a parachute mine on the night of 18 November 1940.

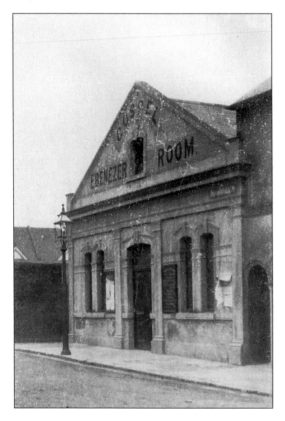

The Baptist (Ebenezer) Gospel Room, Rossendale Road, was built between 1878 and 1882. The chapel became the Junction Engineering Works run by the Hennings brothers in around 1920. The building was destroyed by a parachute mine on 18 November 1940. The roof tops on the left are in Morrison Road.

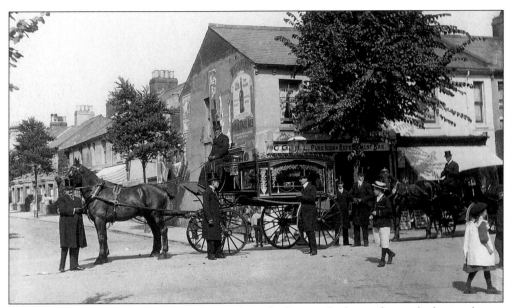

A horse-drawn funeral carriage, c. 1910. The vehicle is parked outside a refreshment bar in Canterbury Road, at the junction with Bridge Street. Note the decorative glass panels around the sides of the carriage, allowing one to see the coffin.

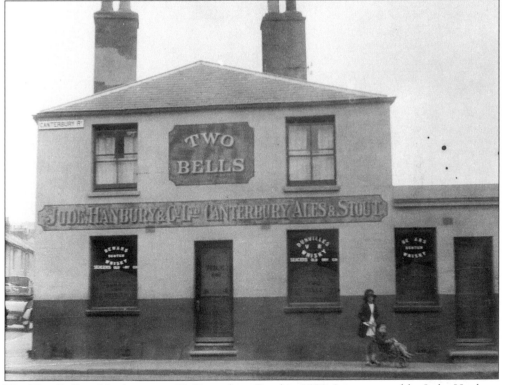

The Two Bells public house, at 58 Canterbury Road, in 1923. It was owned by Jude, Hanbury and Co. Ltd, makers of Canterbury ales and stout. The first reference to the Two Bells is in 1855 and it was taken over by Mackeson in 1924.

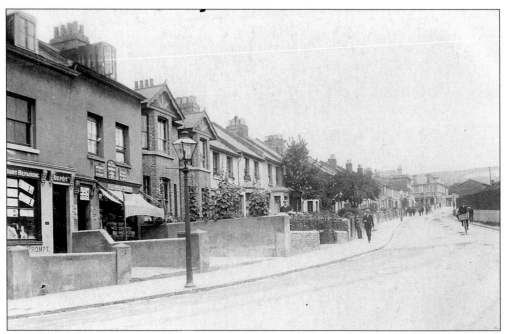

Dover Road from the Skew Arches, 1905. On the left is Mr F. Ray's boot and shoe shop, followed by Mr A. Huckstepp's tobacconists. These two shops have now been converted into houses. Behind the wall and fence on the right hand side is a row of thirteen houses, known as 'Station Cottages'. They were built for railway workers.

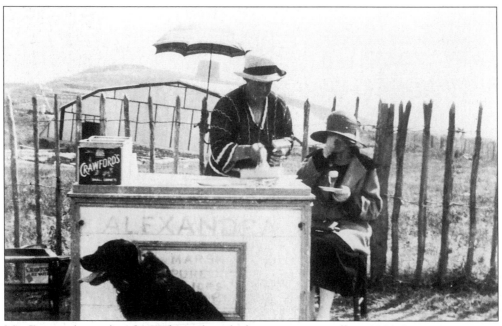

Mrs Frances (sitting) and Maud Marsh with their ice cream stall, c. 1934. It is interesting to note that the building behind the ice cream stall is covering the Roman remains.

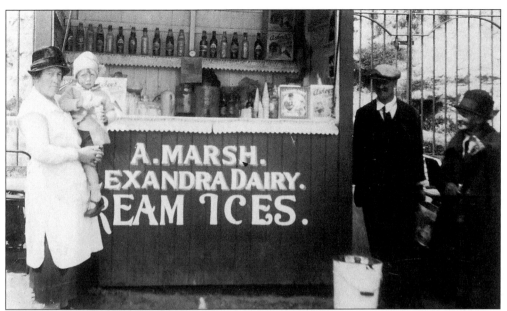

A. Marsh's Alexandra Dairy, *c*. 1934. This photograph was taken in the Warren. From left to right: Mrs Frances Marsh, Mr Ralph Canning, Mrs Corneal.

Black Bull Road in 1928. The shop on the right at the junction with Fern Bank Crescent was demolished by a high-explosive bomb on 12 August 1940.

Mr Brightman, a fish hawker, in 1922. Mr Brightman was photographed here outside 14 Walton Road by the author's mother, Rosie Taylor (née Ryall).

Charles Quaiffe, bootmaker and repairer, of 26 Allendale Street, at the junction with Albert Road. Mr Quaiffe was in business at these premises from 1920 to between 1940 and 1947. From left to right are Tom, Albert and Ethel Quaiffe.

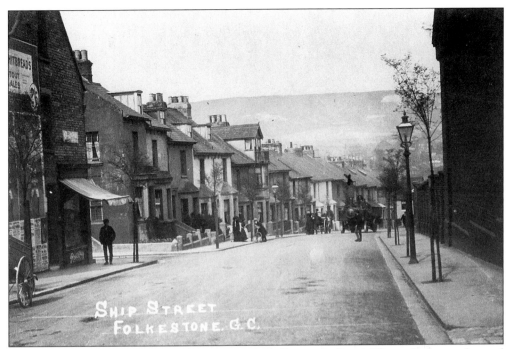

Ship Street, 1906. On the left is the junction with Boscombe Road. The eight houses beyond the junction were demolished by a high-explosive bomb on 24 April 1942. The site is now occupied by the Air Training Corps No. 99 Squadron. Note the steam lorry making its way up the hill.

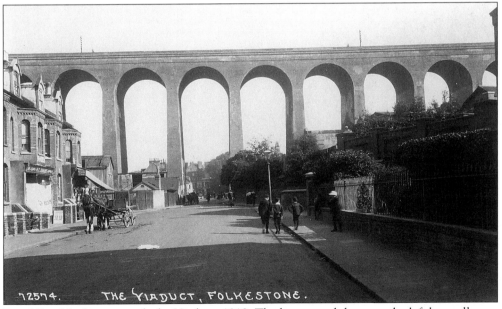

Foord Road looking towards the Viaduct, 1912. The houses and shops on the left have all gone and the site is now occupied by Dove's Main Ford Dealers.

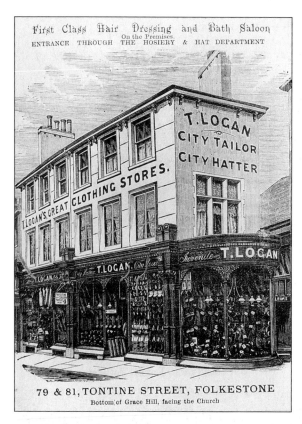

A tailors and outfitters run by Mr T. Logan along with a hairdressing and toilet salon, 79-81 Tontine Street. Mr Logan certainly gave a variety of services at his premises! He was in business from around 1883-87 to 1893, when the business was taken over by R.G. Wood.

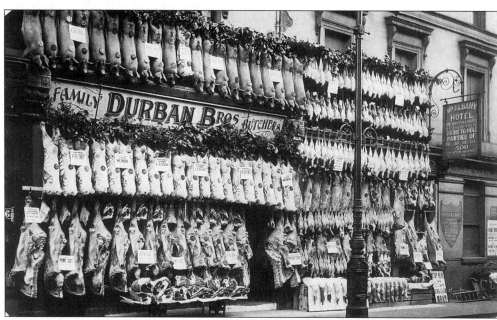

Durban Brothers, butchers at 40 Tontine Street. The picture is of Mr Durban's fine display of meat for Christmas 1913. He traded at these premises from 1903 to 1938. The shop was a butcher's from 1889 to 1956; it is now the Windsor restaurant.

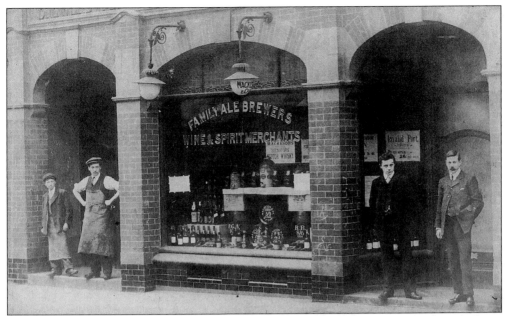

This off-licence at 40 Tontine Street was owned by Mackeson and Co. Ltd, who were brewers and wine and spirit merchants from Hythe. Mackeson's were in business at these premises from between 1882 and 1887 to 1923, when it was taken over by Fremlins Brewery. The business closed around 1969.

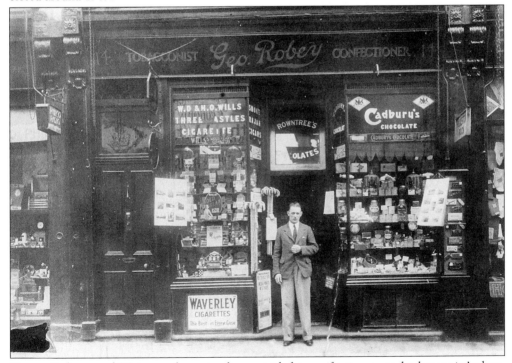

George Robey, aged 26, is seen here standing outside his confectionery and tobacconist's shop, 14 Tontine Street, in 1932. Mr Robey ran this shop until a few months before he died in November 1994. The business closed in April 1997.

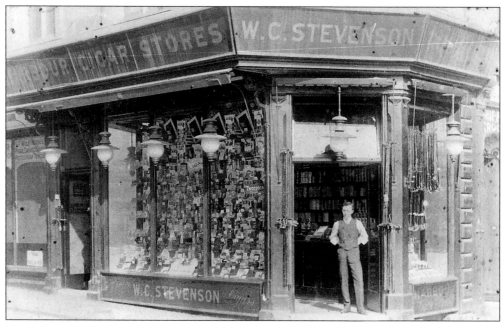

William C. Stevenson, tobacconist, 2 Tontine Street. Mr Stevenson conducted his business from these premises from 1906 to 1938. Mr Orchard, an employee, is standing in the doorway. The premises are now occupied by Jolson's bar.

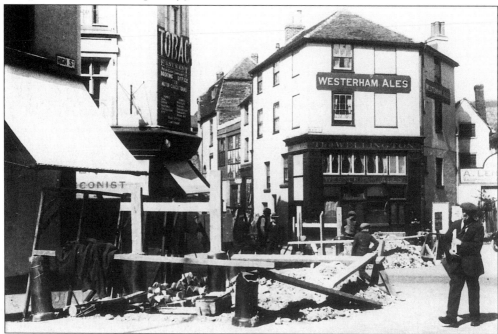

The Wellington public house, formerly the British Colours, 1 Beach Street. The Wellington was first licensed on 25 August 1869, when it was known as the 'Commercial Coffee-house'. The building was destroyed by a parachute mine on 18 November 1940. The spirit licence was transferred to the Lifeboat Inn on 29 February 1956. The photograph was taken for the road works in around 1930.

Three
Around the Harbour

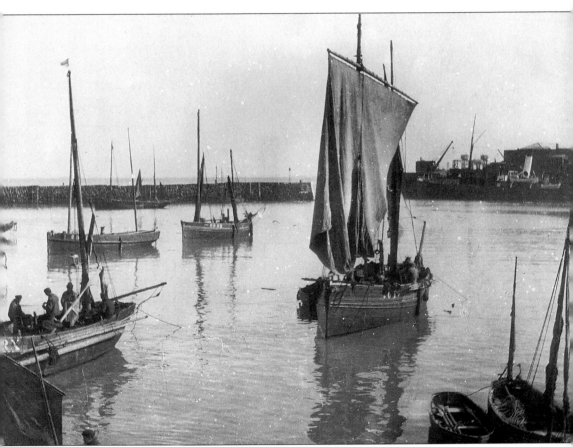

The Outer Harbour, 1898. The Harbour looks rather sparse, as quite a number of the fishing luggers are at sea. The boats left in the harbour are not all registered at Folkestone: there is one boat from Rye and one from Shoreham.

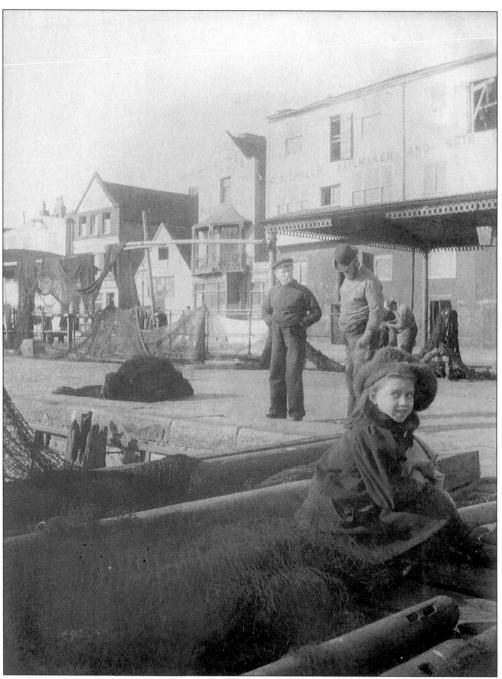

The Stade, with fish sheds Nos 2 and 3, 1898. The buildings from left to right, starting with the one with the pitched roof, are: the Jubilee public house, H. May and Co., fish salesmen, the Odd Fellows Arms and G. Nicholls, sail maker. The little girl in the foreground is sitting on the fishermen's jetty.

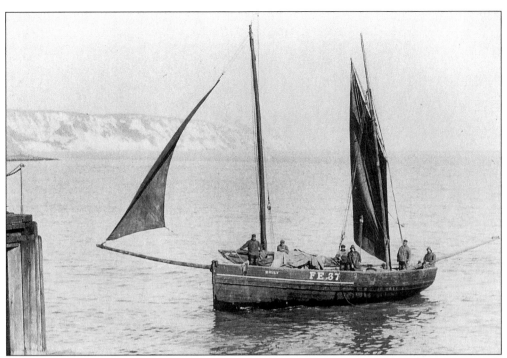

The fishing lugger *Emily*, registered FE37, approaching the Harbour mouth. The photograph was taken between 1905 and 1911. The skipper and owner is Henry 'Chunk' May; he is seen here standing aft, steering the vessel.

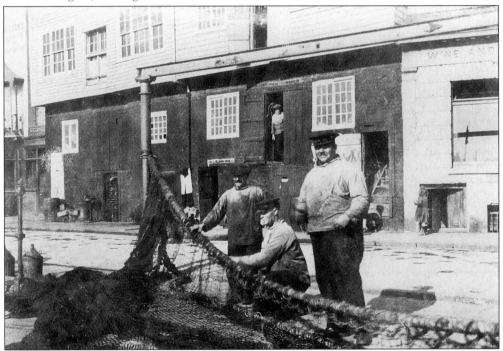

Fishermen tying their trawl net on to the ground rope, *c.* 1920. They are, from left to right: Jimmy Carter, 'Fairy' Hart and Henry 'Chunk' May.

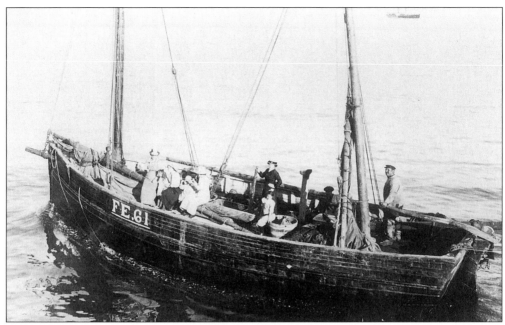

Fishing lugger *Young Harry*, registered FE61, on engine trials, *c.* 1920. Skipper and owner Henry 'Chunk' May is steering the vessel and just forward of the mizzen mast can be seen his wife (standing) and their daughter Grace (sitting). *Young Harry* was blown up by a mine on 1 January 1940 and all hands were lost, including Fred Weatherhead Snr, Fred Weatherhead Jnr, William Foad and Richard Cornish.

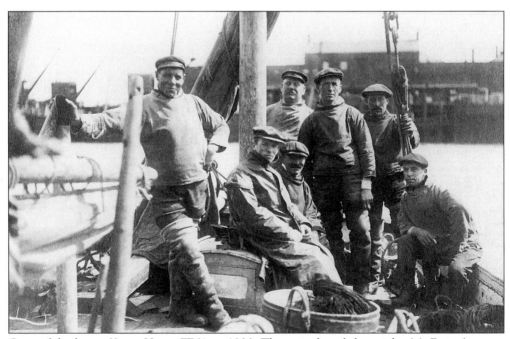

Crew of the lugger *Young Harry*, FE61, *c.* 1920. They are, from left to right: Mr Fagg, (a paper reporter), Jimmy Carter, Henry 'Chunk' May (skipper), Richard Cornish, Bob Baker (engineer) and Mr Shrewsbury.

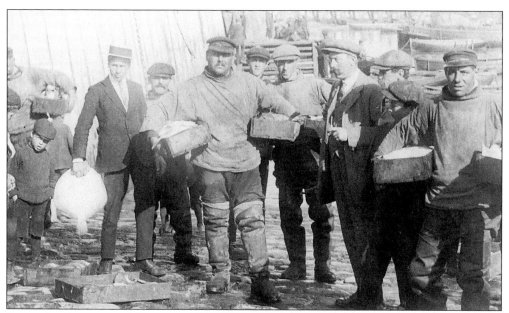

Posing for the camera is the crew of the fishing lugger *Young Harry*. They are seen here landing their catch in around 1920. The man standing next to Henry May holding the fine turbot is his cousin.

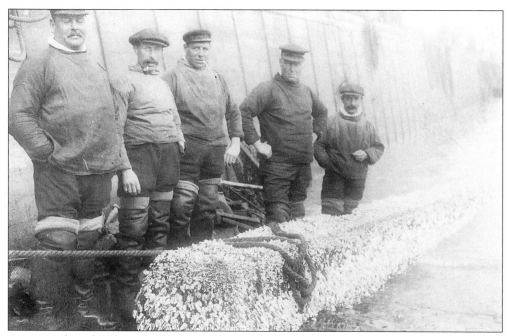

An unusual catch! The crew of *Young Harry* towed this large baulk of timber in from the English Channel, because it was a danger to shipping, in around 1922. The crew from left to right are: Henry May, Bob Baker, Dick Fagg, Bill Hart and Jimmy Carter.

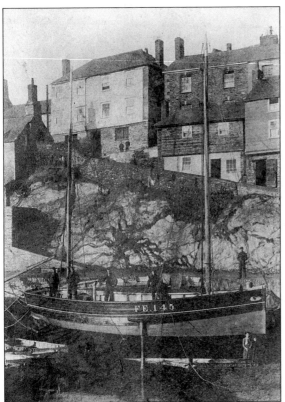

The sailing lugger *Masterpiece*, registered FE145, is seen here at Mevagissey in 1903. FE145 was built for fisherman Alfred May. She was 39 ft 5 ins long by 14 ft wide and she had a beam of 6 ft. The photograph was taken just before she sailed for Folkestone.

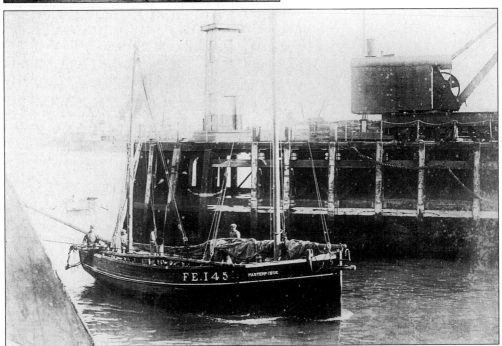

The *Masterpiece* entering the harbour, *c.* 1926. The vessel is seen here after she has had an engine fitted, but the sails were still used for extra assistance.

Fisherman George Baker is seen here standing on the quay with his daughter Edith and granddaughter Maud in 1938. Mr Baker was born in 1855 and died in 1940.

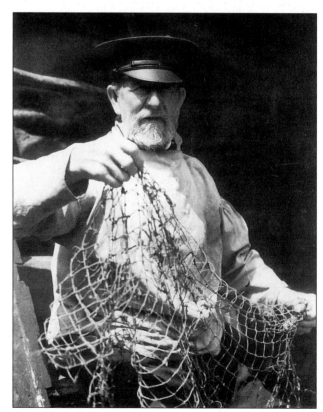

George Baker posing for the camera with some netting, 1938. Mr Baker has 'swallowed the anchor', a term used for a fisherman who has retired.

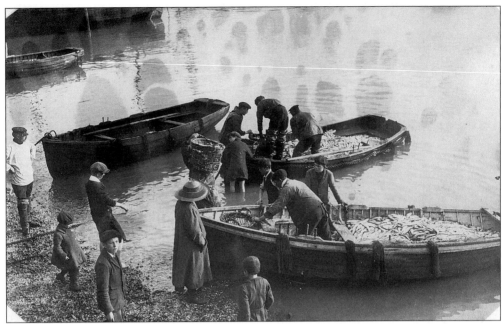

A record catch of herrings, November 1913. The fishermen have off-loaded the herrings from the luggers and are seen here bringing them ashore in their punts (rowing boats). The herrings all had to be counted; they were counted in fours. Four herrings equalled one 'warp' and ten thousand herrings equalled one 'last', while a last with a hundred extra for broken fish made a 'last plus'.

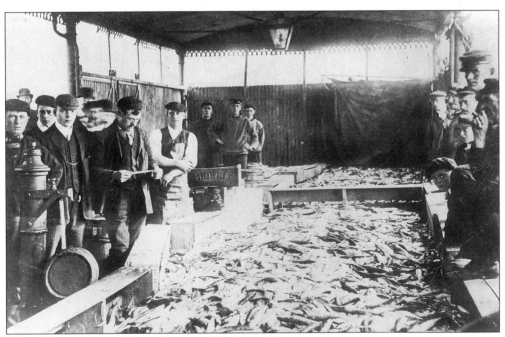

A record catch of mackerel in fish shed No. 3, *c.* 1910.

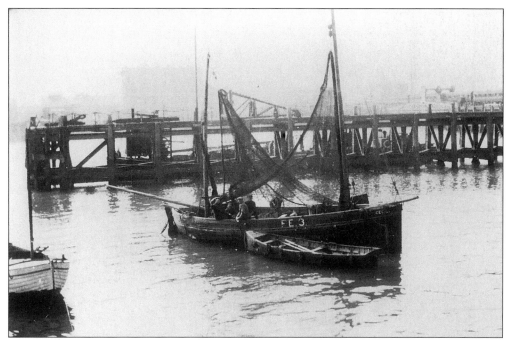

The fishing lugger *Cecil*, registered FE3, *c.* 1925. The *Cecil* was a double-ended boat (i.e. pointed at both ends) and her skipper-owner was Thomas Henry Baker. She is seen here on her moorings between the Quay and Hawk (the wooden jetty).

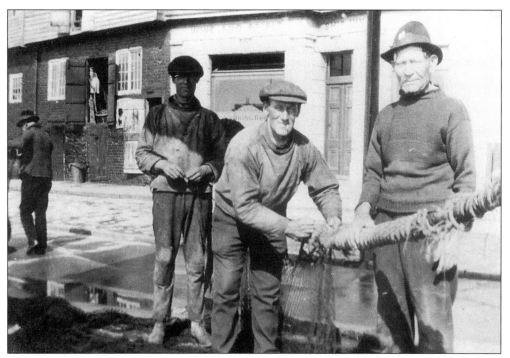

Fishermen tying their trawl net to the ground rope in the 1920s. They are, from left to right: -?-, George Avery and Mr May. The building behind them is the old Ship Inn.

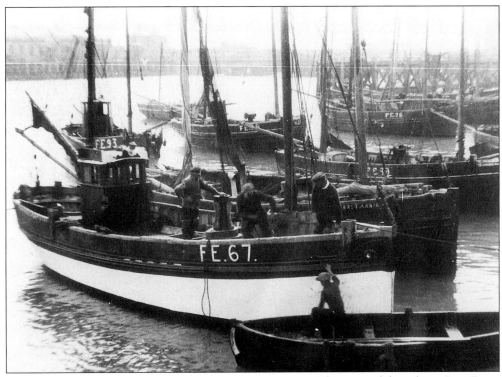

The motor fishing boat *Carn Du*, FE67, in September 1931. *Carn Du* was built in Newlyn in 1920 and she was the first purpose-built motor fishing boat at Folkestone. The skipper-owner was Alfred May.

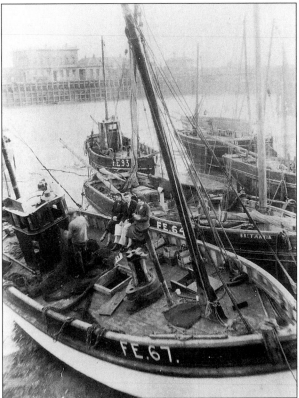

The tide is out and the *Carn Du*, among other fishing boats, has taken the ground, 1931. Alfred May is seen here with his back to the camera, mending his trawl net.

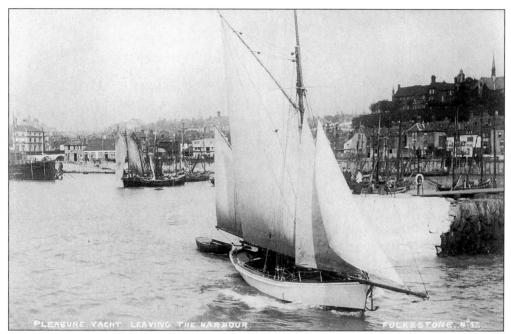

The *Mazie*, a sailing pleasure boat, is seen here leaving Folkestone Harbour, August 1921. Folkestone had two sailing pleasure boats, the *Girtie* and *Mazie*, both owned by Thomas Henry Baker. They operated from the Harbour or the beach near the Victoria Pier.

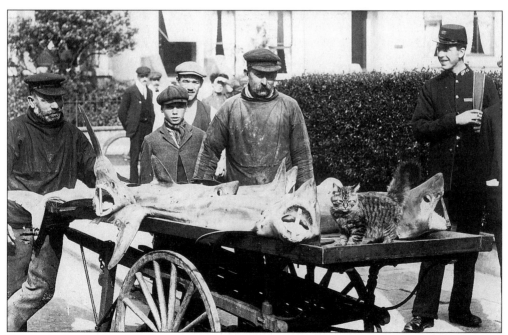

Young sharks caught off Folkestone, 1910. The fishermen are taking them around the town on a hand-barrow to raise money to replace their torn nets. Note the cat and the postman.

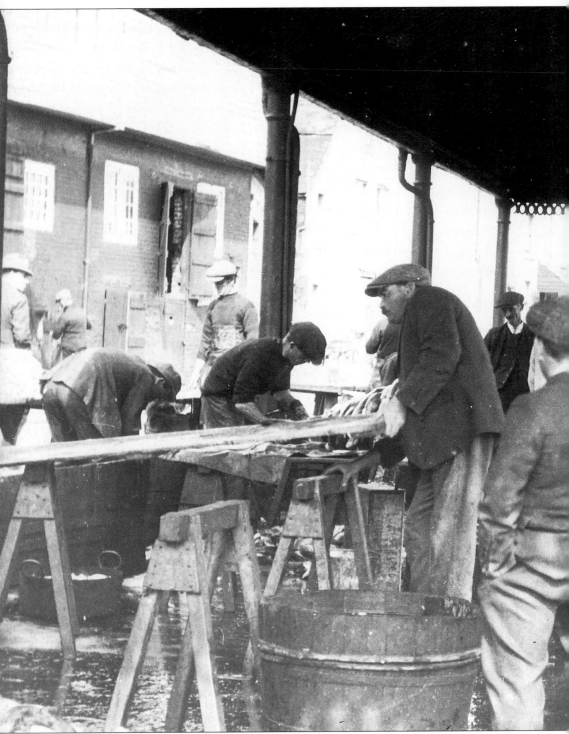

A busy scene in fish shed No. 2, cleaning dogfish, 8 May 1923. In the foreground to the left with his back to the camera is fisherman Albert 'Nobby' Taylor; immediately in front of him is Arthur Goddard, a fish salesman.

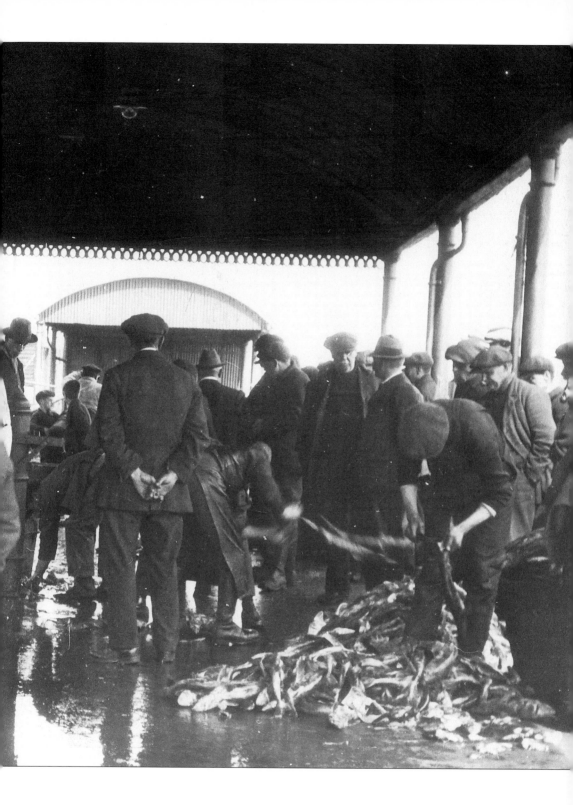

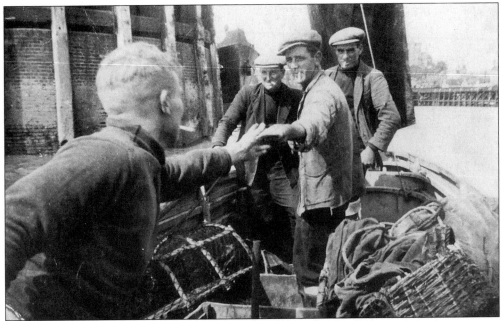

The fishermen seen here leaving the Harbour are going fishing for lobsters and crabs, *c.* 1938. They are, from left to right: Harry 'Knocker' Brice, David 'Lurgy' Milton, Dick Spearpoint, -?-.

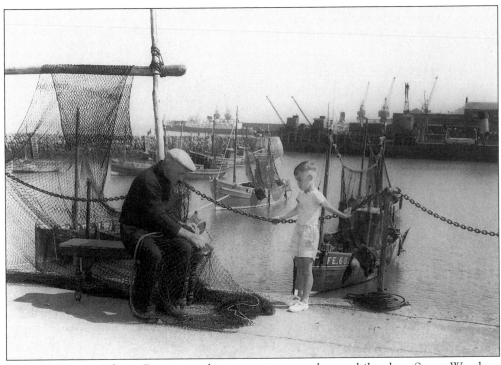

Retired fisherman Johnny Fagg is seen here repairing a trawl net, while a boy, Stuart Weatherhead, looks on, *c.* 1958.

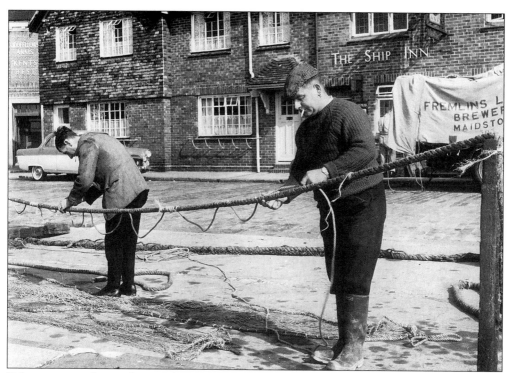

Fishermen spend many hours ashore preparing their fishing gear. Here, Alec Boorn (left) and La-La Taylor are making a ground rope for their trawl net in around 1961.

Fishermen Albert 'Moe' Baker and Bill Andrews are going fishing to catch crabs, lobsters and whelks. They are on board the fishing boat *Lady Hamilton*, FE47, in around 1961.

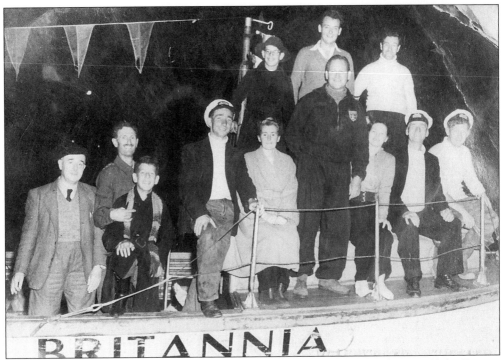

On board the pleasure boat *Britannia*, *c*. 1952. The occasion is a channel swim: Philip Rising, from Rotherham, Yorkshire, has swum the Channel from France to England in 18 hours 38 minutes. From left to right are: -?-, -?-, -?-, David Sharp, -?-, Philip Rising (swimmer), Miss Rising (his daughter), Harry Sharp (skipper and boat owner), Harry Sharp Jnr, and the man behind in the white jumper is Jack Darby.

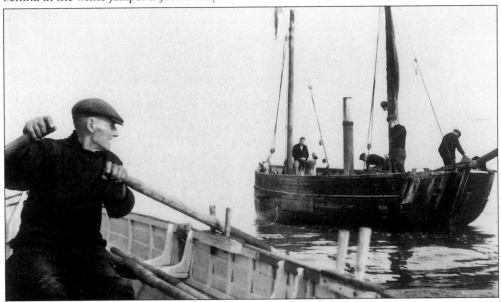

The fishing boat *Invicta*, FE68, is seen here escorting a Channel swimmer, *c*. 1954. The skipper, Reg Brickell, is standing by the mizzen mast; in front of him, bending down, is crew member Tom Spearpoint and aft is Dick Spearpoint. Mr 'Hollaway' Pegden is rowing.

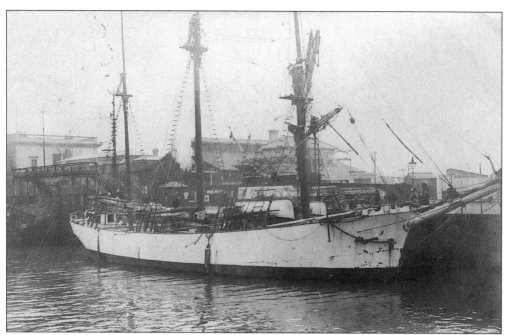

A large sailing ship moored in the Inner Harbour, 1904. This barquentine has a steel hull. She is unloading a cargo of timber, possibly from the Baltic.

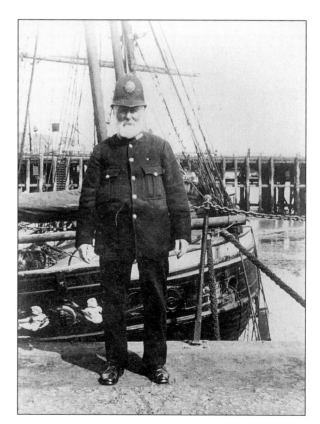

Folkestone Harbour policeman, Mr May, c. 1910. Mr May was a cousin of fisherman Henry 'Chunk' May. Note the figures on the side of the sailing ship. She has come from Norway or Sweden with a cargo of ice.

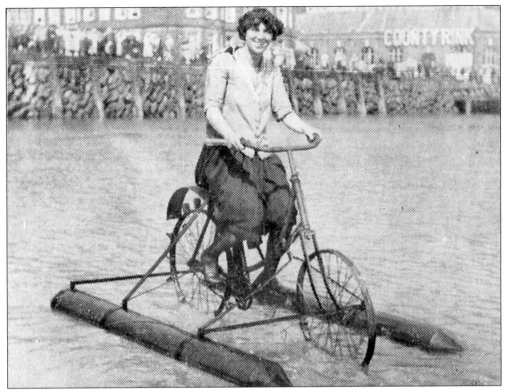

Miss Zetta Hills at the Inner Harbour. Miss Hills crossed the Channel on this water cycle in sixteen and a half hours, covering forty-seven miles on 16 August 1920.

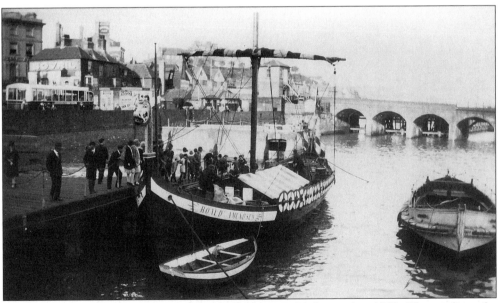

A Viking ship moored at the Inner Harbour slipway, 24 September 1929. This replica of a Viking ship, named *Roald Amundsen* after the famous explorer, came from Norway. She visited Folkestone for two days while making a coastal tour.

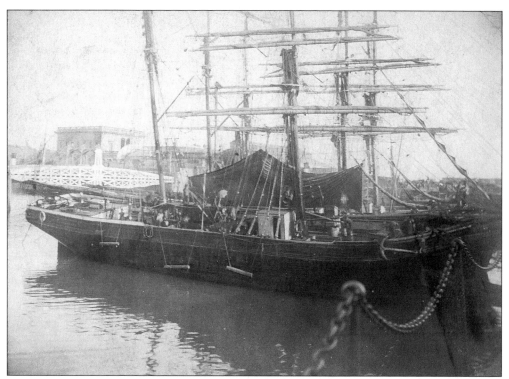

The Inner Harbour thronged with sailing ships, September 1896. Long gone are sights like this when the harbour was bustling with ships unloading their cargoes of coal, timber or ice. Most of these ships left Folkestone with cargoes of chalk.

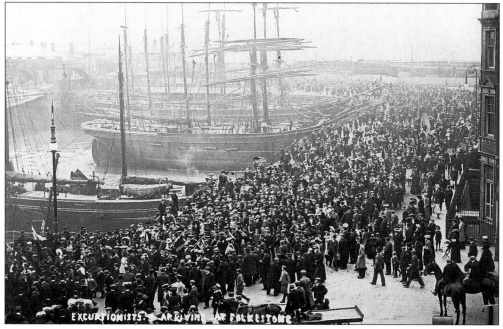

Excursionists arriving from France, 1908. Today the reverse applies: more British people take day trips to France.

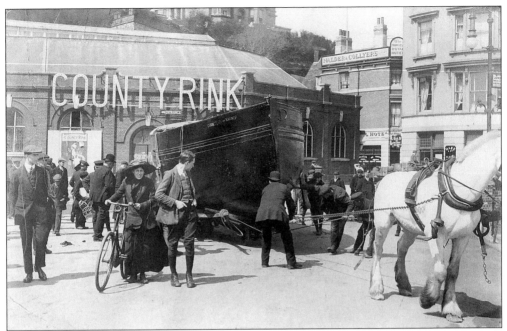

The *Countess of Radnor*, FE166, about to be launched from the Inner Harbour slipway, July 1913. Reg Spicer lost his fishing lugger, *Mose Rose*, during a storm on 29 November 1912. The money to build him a new boat was raised by public subscription, started by Lord Radnor.

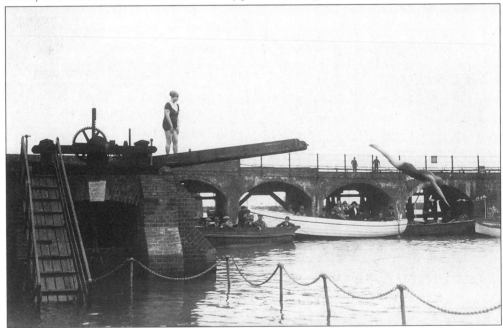

In connection with a Shopping Week, the Folkestone Swimming Club held some highly successful aquatic sports in the Inner Harbour on Wednesday 20 June 1923. There was a tremendous number of spectators, with three sides of the harbour crowded with people. The picture is of the diving display from the Pent Stream sluice gate, organized by Miss Timbroll and Miss Cloake. Those taking part were: Harris, Hammond, Grinstead, Webb and Baker-Heyes.

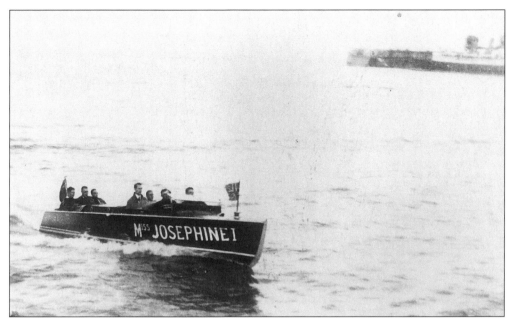

Miss Josephine 1 was an eight-seater pleasure speed-boat, owned by Tom Penny and driven by Cecil Brickell. She ran trips round the bay in the 1930s.

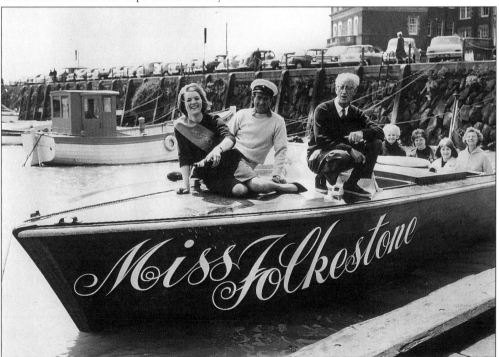

Christening the pleasure speed-boat *Miss Folkestone*, 29 May 1965. Seen here from left to right are: Valerie Atkins (Miss Folkestone), Alan Taylor (skipper and part owner) and Alan's late father, Fred. The vessel was built in Lyme Regis and was fitted with a 145 horsepower, six-cylinder, turbo-charged Perkins diesel engine, which gave her a speed of twenty-five knots. *Miss Folkestone* carried twelve passengers.

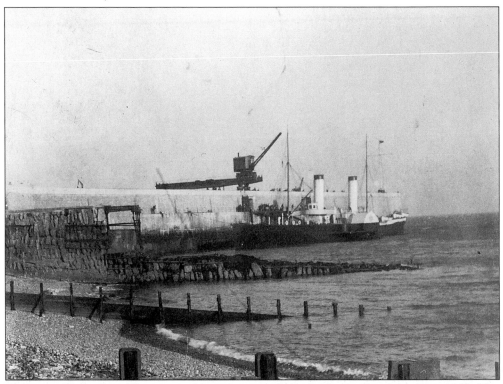

The cross-Channel paddle-steamer *Victoria*, moored on the west side of the Pier, 1904. The vessels usually moored on the west side of the Pier when the wind was blowing from the east.

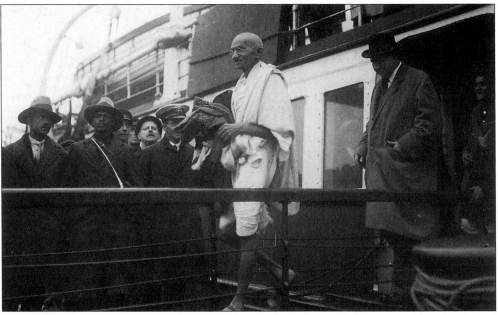

Mr Gandhi, the Indian Congress leader, and a number of other delegates to the India Round Table Conference arrive at Folkestone Harbour by the SS *Biarritz* on 12 September 1921, on their way from Boulogne to London.

Four
Events

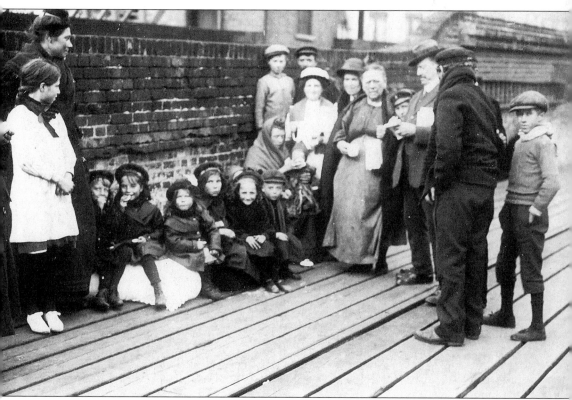

Belgian refugees at Folkestone, 1914. These Belgian families are on the wooden jetty at the side of the railway branch line to the Harbour.

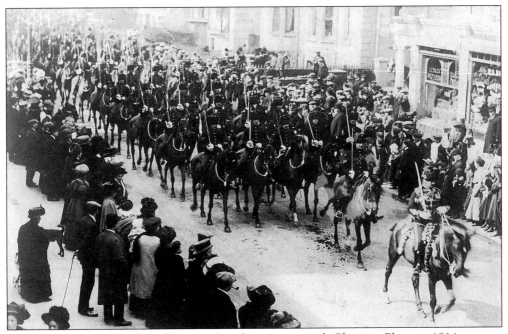

The Hussars Regiment in Sandgate Road at the junction with Cheriton Place, *c*. 1914.

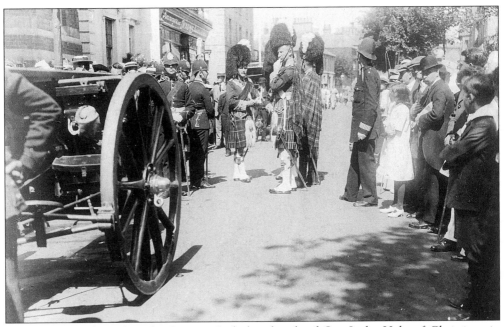

A gun-carriage funeral at the Roman Catholic church of Our Lady, Help of Christians in Guildhall Street, 1915.

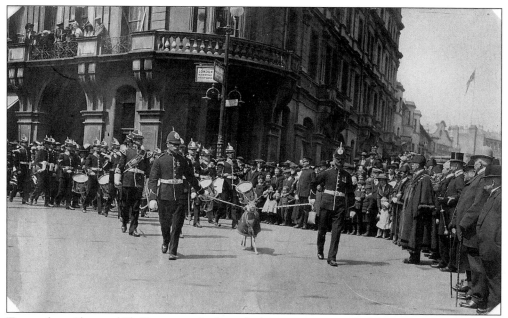

Troops from Shornecliffe Camp parade through the town, passing the Mayor, Mr Mumford, and Corporation at the Town Hall, 1913. Among the regiments are: the Seaforth Highlanders, the Warwickshires, the Hussars, the Royal Artillery and the Irish Fusiliers who are leading with their goat.

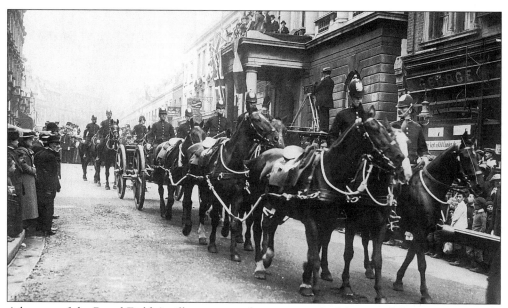

A battery of the Royal Field Artillery are seen here passing the Mayor and Corporation outside the Town Hall, 20 June 1914. Note the photographer to the right of the centre, who is using an early cine camera.

The Folkestone Company of the Veterans' National Reserve, November 1913. The Veterans muster to attend church with the Mayor, Sir Stephen Penfold, at the Baptist church, Rendezvous Street.

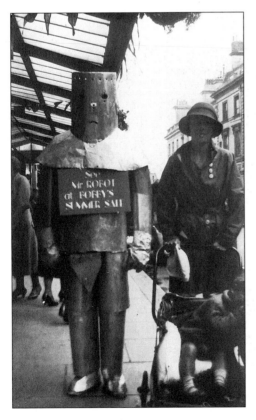

A robot under the canopy of Bobby's department store, 1930s. The notice proclaims: 'See Mr Robot at Bobby's Summer Sale'.

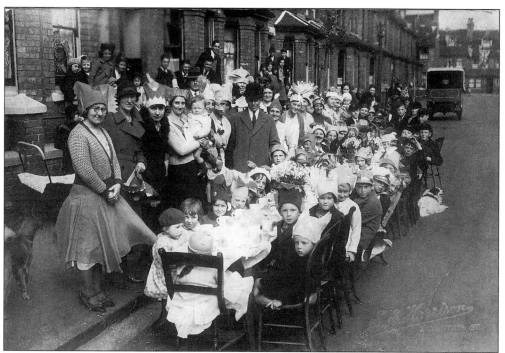

A street party in Ethelbert Road, possibly to celebrate the coronation of George VI on 12 May 1937.

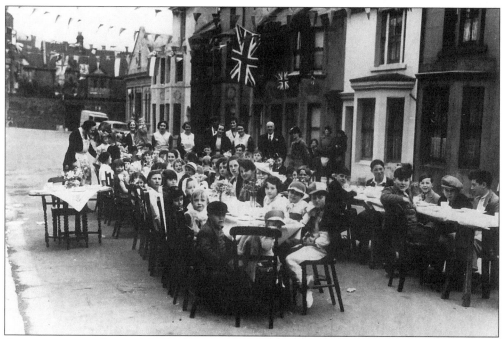

A street party at Rossendale Road, to celebrate King George V's and Queen Mary's Silver Jubilee, 6 May 1935.

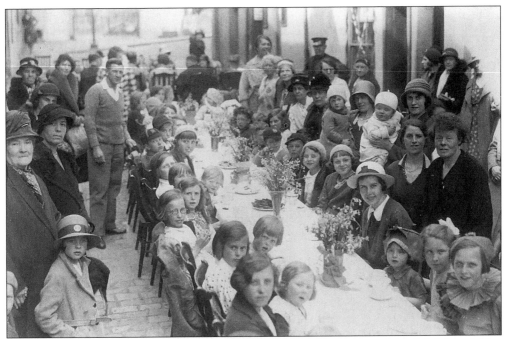

A street party in North Street to celebrate King George V's and Queen Mary's Jubilee, 6 May 1935. Among this group are: Mrs Carey, Stan Taylor, Josie Brickell, Joan Tilly, Doreen Milton, Dorothy May, Cissie Sharp, Lilly Taylor, Lilly Sharp, Mrs Care, Mrs Milton, Mrs King, Mrs Starling, Mrs Warman, Jessie May and Mrs Jenner.

A street party in North Street, outside the Lifeboat Inn, c. 1935. Among the people in this group are: Rod Jenner, Mrs May, Mr Phillips (headmaster of St Peter's School), Father Ostrean, Emily May, Lilly Taylor, Mrs Starling, Mrs Milton, Stan Taylor and Lilly Sharp.

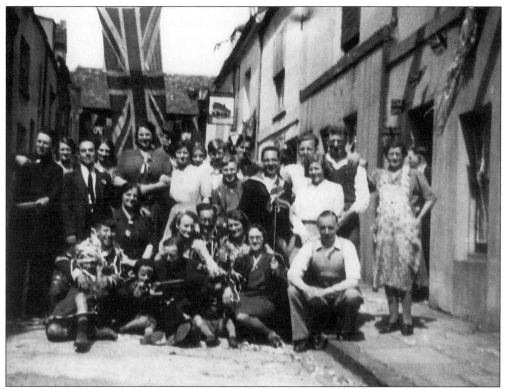

Victory celebrations at the end of the Second World War in North Street, 1945.

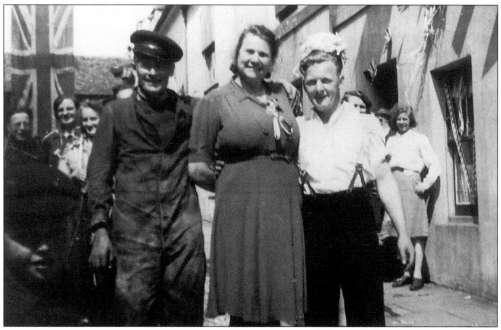

Second World War victory celebrations in North Street, 1945. From left to right are: Bill Petts, Beryl Wooderson (née Spencer), -?-, Charlie Wells, Emily May (née Fagg), -?-.

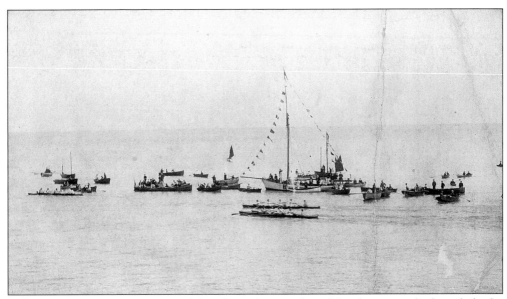

Folkestone Regatta, August 1911. Many boats have gathered for the races which include the rowing club championships, the old fishermen's race and the sprat boat race.

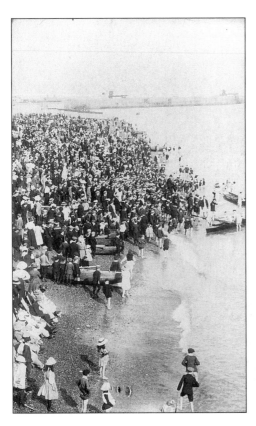

Folkestone Regatta, August 1910. The beach is packed with people watching the boats preparing for their races.

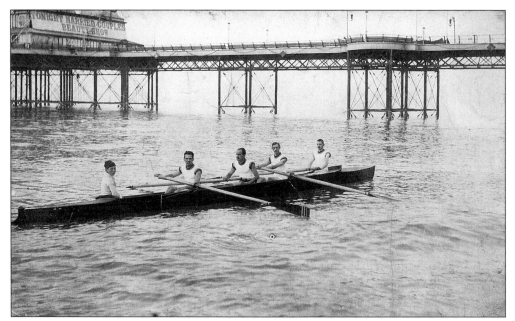

Folkestone Regatta, August 1911. Folkestone's senior fours are seen posing for the camera. Perhaps they have won their race!

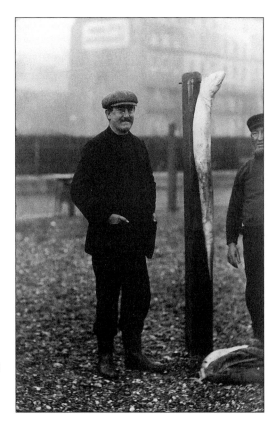

This gentleman has won the regatta angling competition, August 1909. He has caught a fine conger eel in addition to a mixed bag of fish, seen at his boatman's feet.

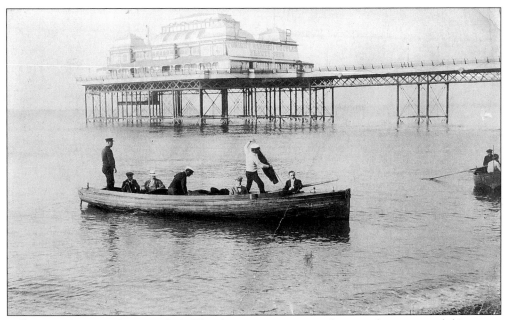

Folkestone Regatta, August 1911. This long, narrow motor boat is the rowing club's escort vessel. Note the show being advertised on the Victoria Pier Pavilion: 'Tonight: Married Couples' Beauty Show'.

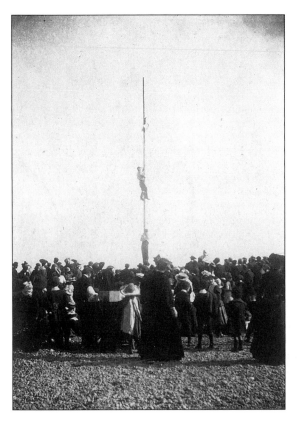

Folkestone Regatta, August 1905. Large crowds have gathered to watch the boys climbing the greasy pole.

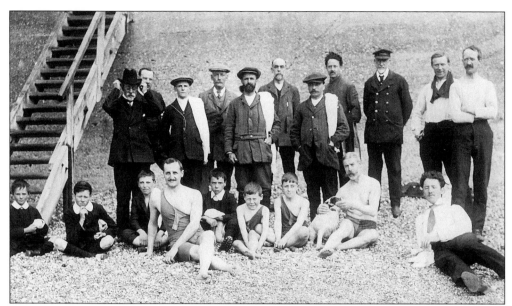

Folkestone's all-year-round sea bathers, 1914. Among this group is Mr Cambourne and William Henry Winter, the Folkestone Corporation Boat Inspector.

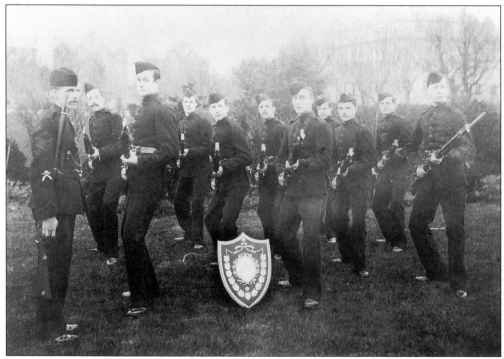

'The Buffs', 1st Battalion East Kent Regiment, c. 1910. This is the winning team of the Sir Bevan Edwards shield, awarded for physical drill and bayonet exercise.

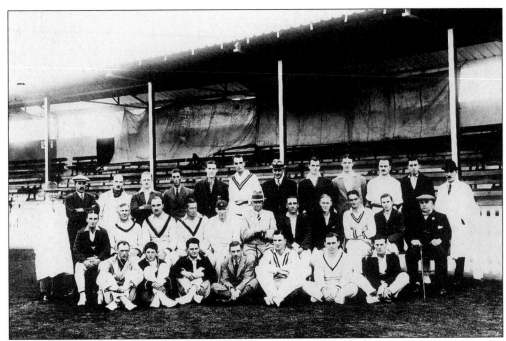

Folkestone Cricket Club v. the rest of the Folkestone clubs, 1926. The other Folkestone clubs are Century, Ramblers, Herald, Municipal Officers, Christ Church and the Crusaders. This match was played to commemorate the opening of the Folkestone County Cricket Ground.

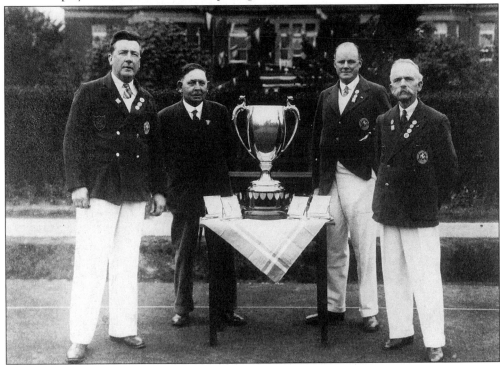

Folkestone Park Bowls Club, the Fifty Guineas Challenge Cup winners, 1937. From left to right they are: E.P. Bridgland (captain), W. Harris, B. Pink and W. Beaney.

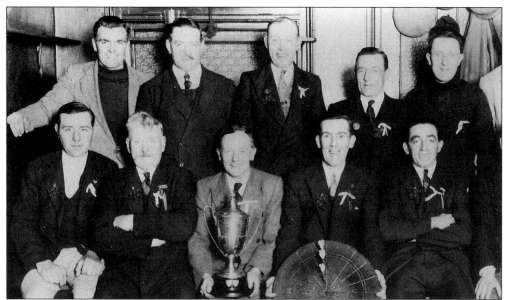

The Wheatsheaf public house, Bridge Street, 1938. This was the winning team in the Folkestone Herald darts league. Front row, left to right, are: -?-, D. Allen, J. Burville (landlord), B. Allen. The landlord, J. Burville, and D. Allen were killed when the Wheatsheaf was destroyed by a V-1 flying bomb on 3 July 1944. In the centre of the back row is Edward Hart, who was killed on the Leas on 5 October 1940, aged thirty-six.

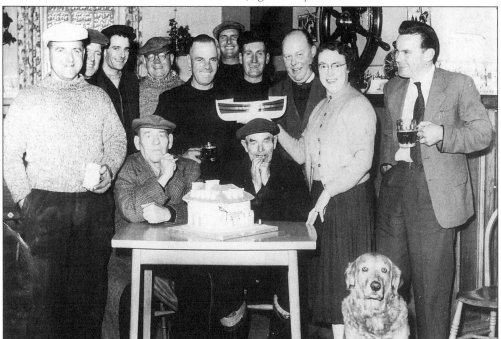

An anniversary gathering at the Jubilee Inn, The Stade, c. 1956. From left to right, standing: La-La Taylor, Stan 'Pommy' Heath, Val Noakes, Roland 'Fergy' Noble, Dick Brickell, Fred 'Churr' Featherbee, Alic Boorn, Don Mayne (landlord), Mary Mayne and Bob Chadwick. Sitting: 'Buller' Hall and Bob 'Kittens' Featherbee.

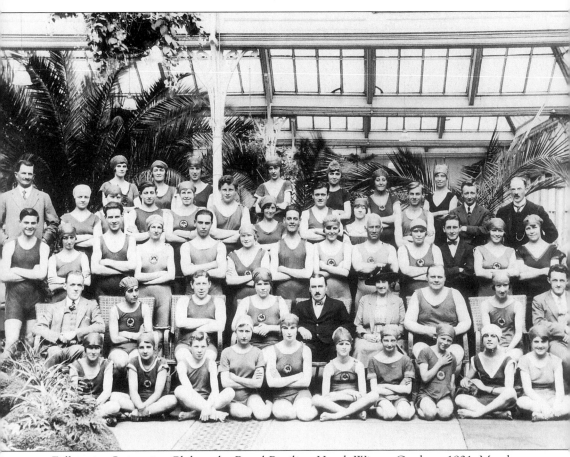

Folkestone Swimming Club at the Royal Pavilion Hotel, Winter Gardens, 1921. Members are ready for a dip prior to the club's annual dinner. They are, left to right, front row: Doris Oclee, Miss Saunders, Bill Jones, Masie March, Mabel Jones, -?-, -?-, Madge Carter, Mrs Binfield and Miss Arthur. Second row: Tom Aylett (club chairman), Mrs Carter (ladies' captain), Harry Ovenden (men's captain), Mrs Carter, Mr Aylett, Mrs Aylett, Doug Spain, Meg Dear and Doug Birch. Third row: Miss Dear, Mr Inge, -?-, Les Carter, -?-, 'Johnno' Johnson, May Timbrill, Mr Ruck, Mrs Spain, Bob Baker, Pearl Carter, Miss Brissenden and Mr Crouch. Fourth row: Arthur Gorely, Miss Brissenden, -?-, Breno Scheggia, Evelyn Wild, Ron Bridgland, -?-, Wally May, Marjory Williams, Arthur Beach, G. Dolton and Mr Luck. Back row: Esmy Oclee, -?-, Minnie Franks, Vera Prichard, -?-, Marie Johnson and Miss E. Dorrell.

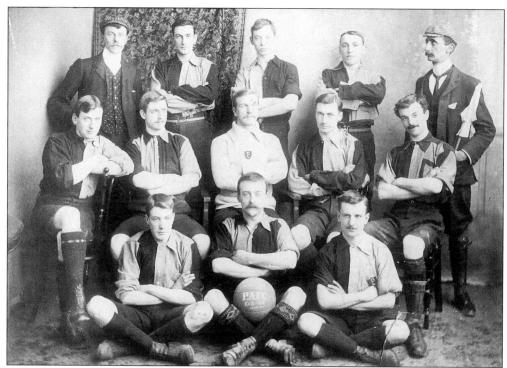

A Folkestone football team, *c*. 1901. Left to right, back row: A. E. Gravett (honorary secretary), R. Webster, P. Brooker, T. Fentiman and W. Pretty (linesman). Middle row: J.R. Crump, C. Simpson (vice-captain), A.E. Benz, J. Smiles and G. Hayman. Front row: E. Leete, A.P. Sleath (captain) and J. Thompson.

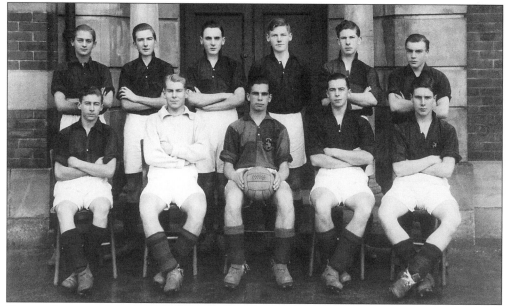

Harvey Grammar School football team, 1937-38. They are from left to right, standing: S.G. Oliver, J.R. Baker, J.H. Holliday, P.L. Plenty, N.P. Taylor and J. Madley. Sitting: S.J. Palandri, W.W. Allen (vice-captain), F.S. Rutt (captain), L.A. Heiser and R. Mackay.

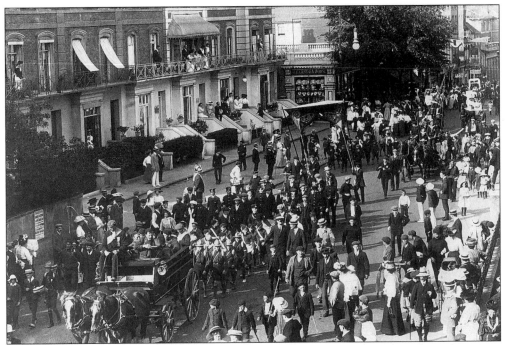

Lifeboat Day, *c.* 1906. The procession is heading up Sandgate Road, led by the lifeboat crew seated in a horse-drawn carriage. The buildings on the left occupy the site where Debenham's department store is now.

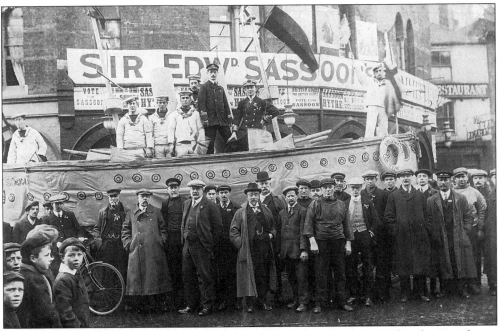

An election float campaigning for Sir Edward Sassoon, 19 January 1910. The photograph was taken in Harbour Street, at the junction with the High Street. The sailors have 'HMS *Sassoon*' on their hat bands and the life buoy has 'HMS *Sassoon* For Hythe'.

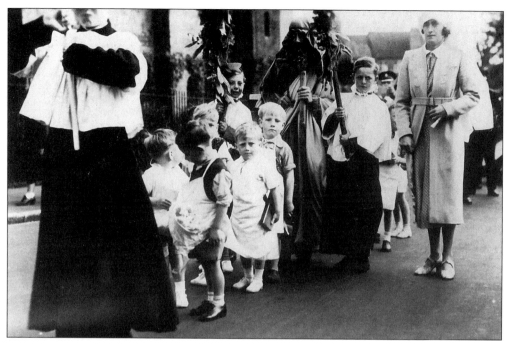

Blessing of the Fisheries Procession, c. 1937. In those days, to get to the Harbour the procession went along the Durlocks to Radnor Bridge Road and down Dover Street (Harbour Way). In this picture is Horace Long and his brother.

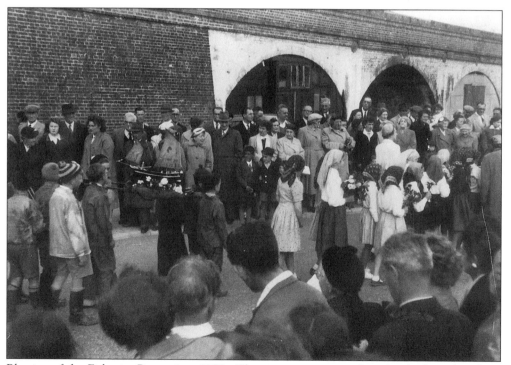

Blessing of the Fisheries Procession, 1950s. The procession is seen here by the branch railway line to the Harbour. Note the four boys carrying a model of a fishing lugger.

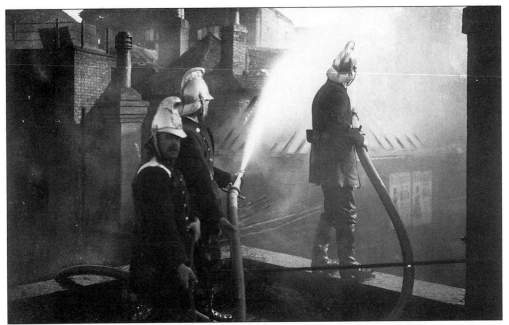

Fire sweeps through the building of George Mence Smith's grocery, oil and hardware store at 8 High Street. The firemen are tackling the fire from the building opposite.

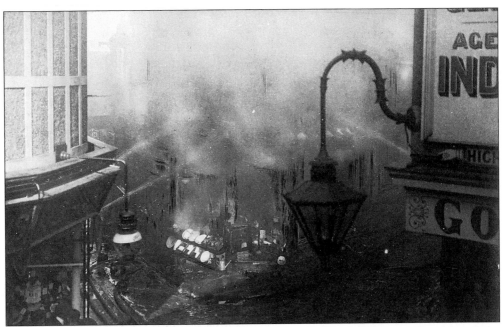

The fire at Mence Smith's shop, seen from George Lane. The building on the right of the picture (at the corner of George Lane) was occupied by Gosling's grocers, provision, wine and spirit merchants.

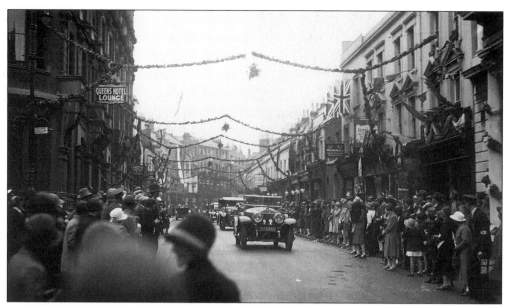

A visit by Prince Henry, Duke of Gloucester, 13 July 1927. The cavalcade of cars is making its way along Guildhall Street. On this visit Prince Henry opened the Leas Cliff Hall and also the extension to the hospital, and laid the foundation stone at the Harvey Grammar School.

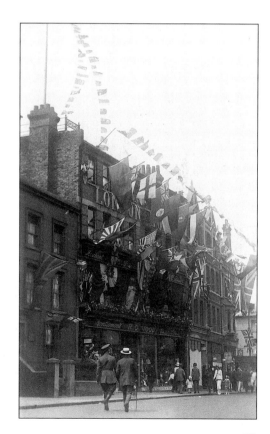

Prince Henry taking a 'walkabout' in Guildhall Street, 13 July 1927. The house on the left is now the Guildhall Camera Centre.

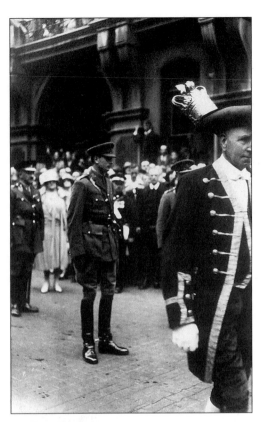

Sandgate Road outside the Queen's Hotel, 13 July 1927. Prince Henry is seen here with the Town Sergeant, Mr Chadwick.

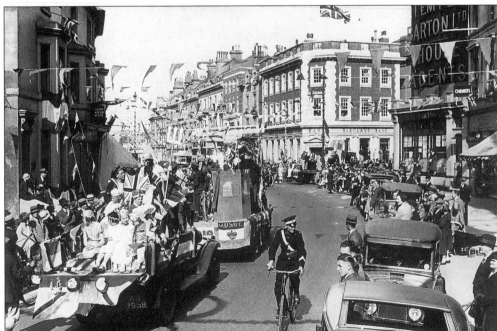

A procession in Sandgate Road to celebrate the Jubilee of King George V and Queen Mary, 6 May 1935.

The Coronation of King George VI and Queen Elizabeth, 12 May 1937. A military band is marching past the Town Hall where the Mayor, Alderman Albert Castle, and the Corporation are standing.

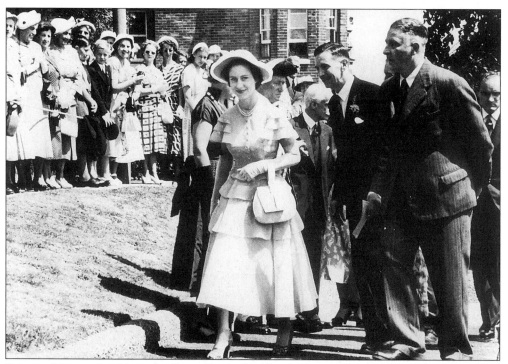

Princess Margaret's visit to the Bruce Porter Children's Home, Wear Bay Crescent, Tuesday 1 July 1952. Her Royal Highness unveiled a plaque to commemorate the installation of a lift, a gift from the people of Folkestone, Hythe and district. (See p. 36 for a picture of the home.)

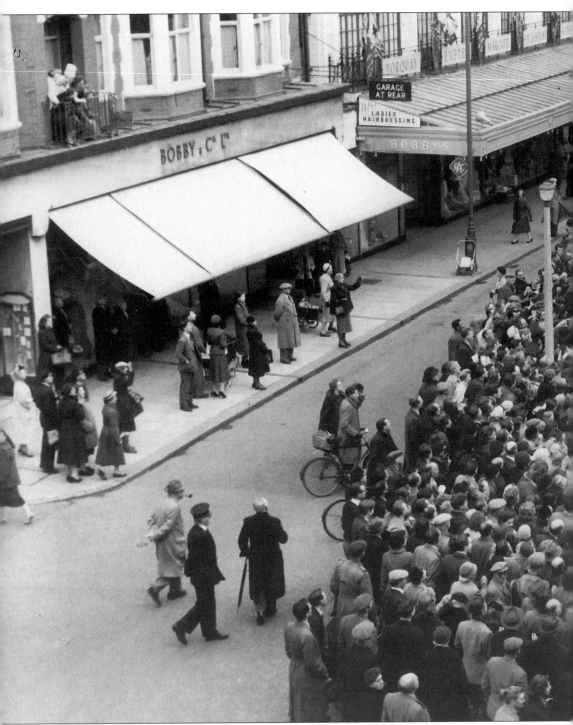

The first visit to Folkestone by HM Queen Elizabeth II and the Duke of Edinburgh, Friday 28 March 1958. The cavalcade of vehicles are seen here in Sandgate Road, on their way to the Leas Cliff Hall, where they were received by the Mayor, Councillor L.V. Fowler, the Council and many other visitors.

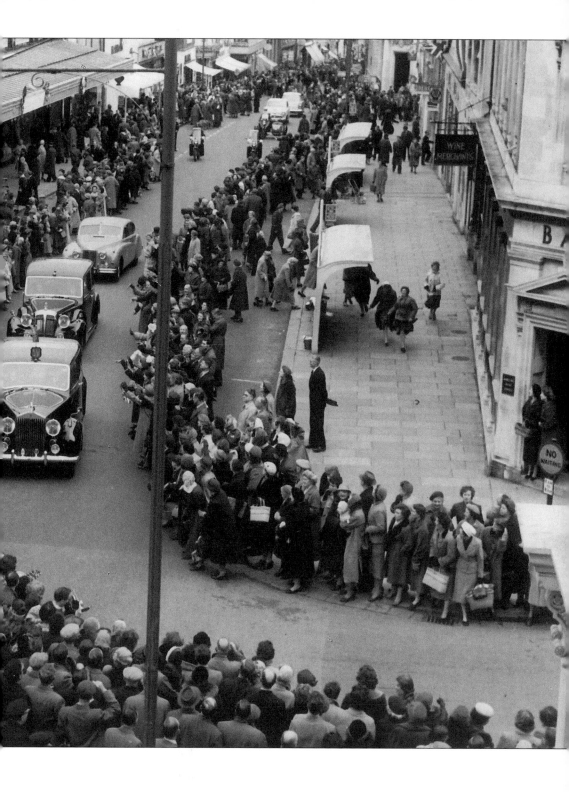

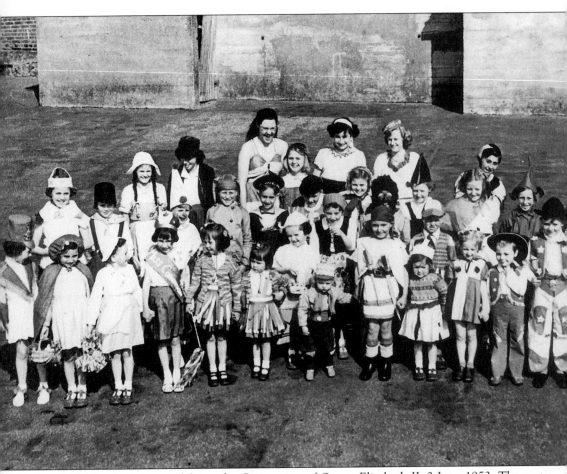

A children's party to celebrate the Coronation of Queen Elizabeth II, 2 June 1953. The party was sponsored by the Lifeboat Inn and the photograph was taken at the Durlocks. Left to right, front row: Diane Hunter, Valerie Shorter, Pat Carter, Vicky Ryan, ? Boxer, ? Boxer, Roy Petts, Barbara Weatherhead, Jennifer Ovans, Michael Hinton. Second row: Irene Tutt, Sylvia Pegden, Michael Sharp, Billy Smith, Peter Neville, Michael Wooderson, Valerie Pegden, Sheila Hinton, Alan Petts, Peter Taylor and Peter Brookwell. Third row: Margaret Noble, Mary Piper, Deanne Sharpe, Pam Sharpe, Geoffrey Evans, Wendy Evans, Marion Taylor, George Smith and Janet Smith. Fourth row: Shirley Mayers, Rita Ryan, Patsie Pope and Donald Shorter.

Five
Transport

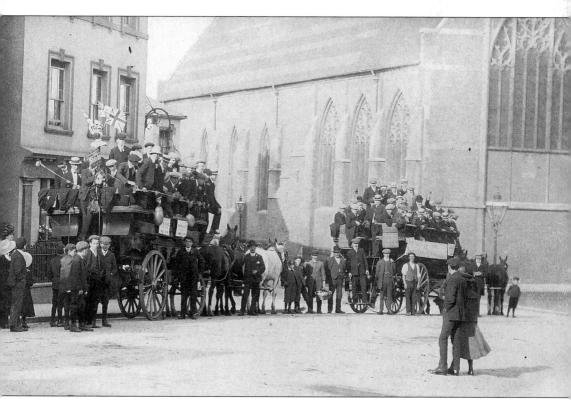

Folkestone butchers' outing from the Harvey Hotel, Dover Road, 1908. The banner on the first horse and brake proclaims: 'Vote for Women and Cheaper Meat'.

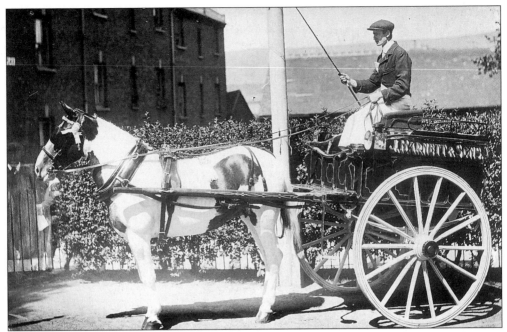

J. Harnett and Sons, butchers, 27 High Street. Mr Harnett won second prize at the Folkestone Horse Show, 1911.

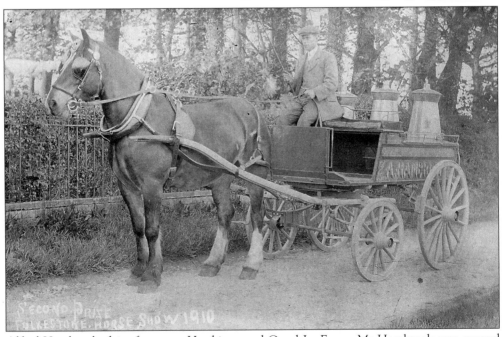

Alfred Hambrook, dairy farmer at Hawkinge and Capel-Le-Ferne. Mr Hambrook won second prize at the Folkestone Horse Show, 1910.

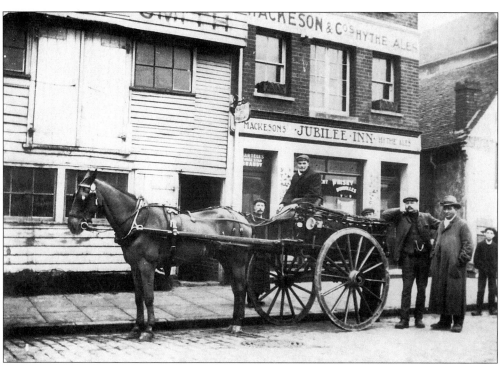

A horse and cart parked outside the Jubilee Inn, The Stade, 1920s.

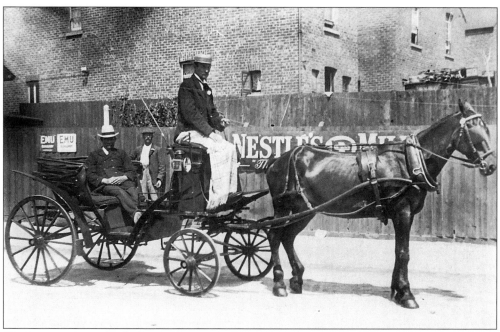

The horse and carriage belonging to Mr Goff (sitting) is being driven by Mr R.A. Coates, 1910. Mr Goff stabled his horses at Alexander Mews.

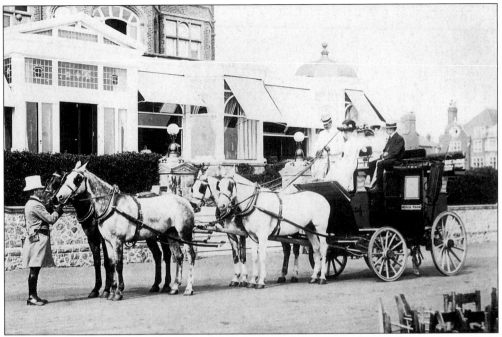

This coach-and-four is parked outside the Grand Hotel, *c*. 1910. The coach has 'Acrise Park' written on the door.

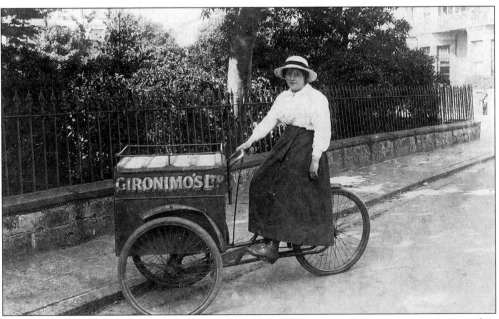

Henry Lorenzo Gironimo started his business at 15 Sandgate High Street in 1890. He moved to 18a Sandgate Road, Folkestone, in 1893 where he remained until 1933. This photograph was taken in Bouverie Square.

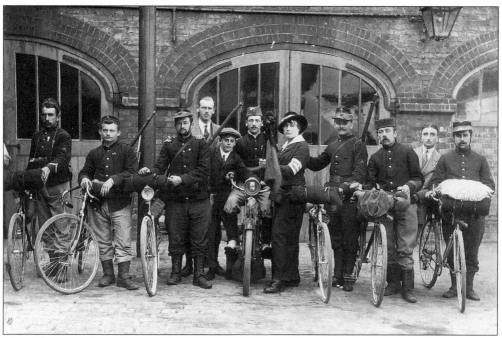

The Belgian Cycling Corps at the Fire Station in Dover Road, during the First World War.

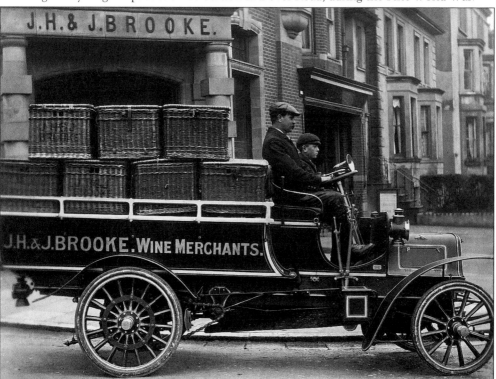

J.H. and J. Brooke, wine merchants, *c.* 1905. The vehicle, parked outside Brooke's Sandgate Road branch, on the corner of Manor Road, is a Delaunay-Belleville built by Maltby of Sandgate and the driver is Harry Mummery.

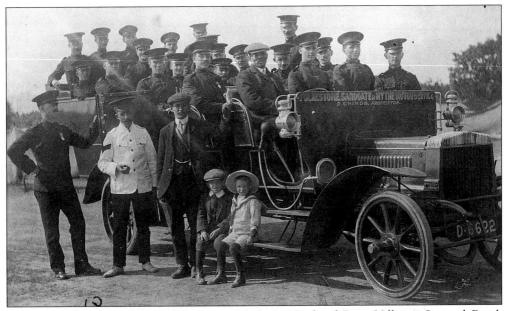

This solid-tyred charabanc, belonging to Mr R.C. Hinds of Rose Villa, 4 Quested Road, Cheriton, is about to take these soldiers on machine gun practice, c. 1913.

A Foden steam wagon, 1914-18. The vehicle belongs to the RAF and was attached to the Capel-Le-Ferne airship station.

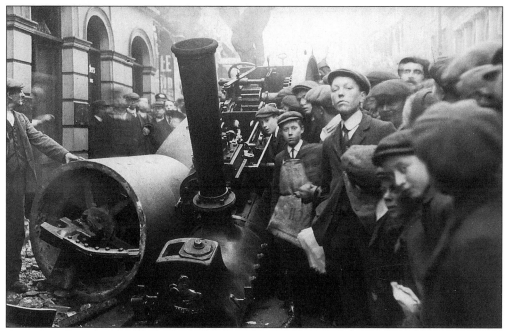

A steam roller accident in Sandgate Road, 4 March 1911. This steam roller from Hythe went out of control in Sandgate Road, smashing into the East Kent Arms and knocking down the entrance and the bar.

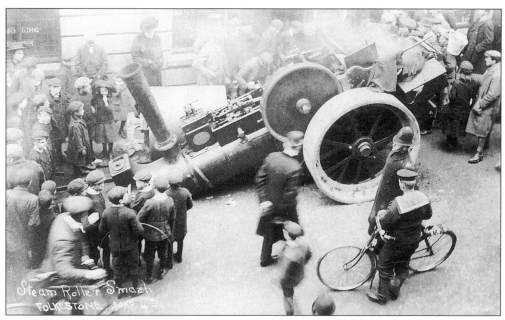

Another picture of the steam roller accident in Sandgate Road, 4 March 1911.

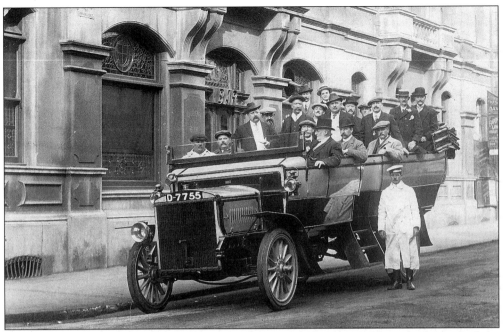

A charabanc outing about to set off from the Queens Hotel, *c.* 1913. The vehicle was built by Maltby of Sandgate and was operated by the Folkestone Motor Co.

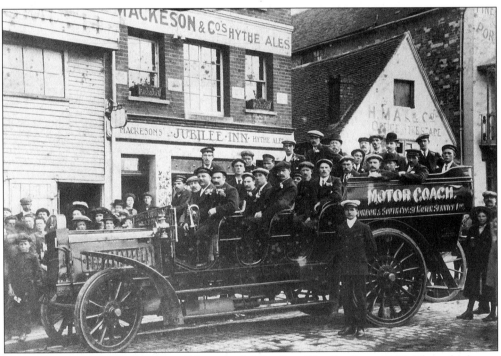

A charabanc outing about to set off from the Jubilee Inn, The Stade, *c.* 1908. The vehicle was designed by Folkestone's John Cann who started the London and South Coast Motor Services' fleet of coaches in Folkestone soon after his arrival in the area in 1901. The large rear wheels were considered to give a smoother ride.

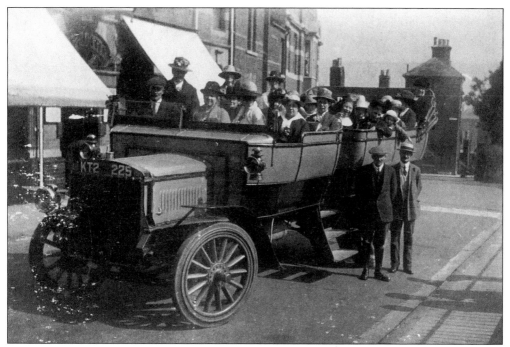

A ladies' outing about to set off from outside the *Folkestone Herald* offices, The Bayle, 1920. The vehicle was owned by Mr E.V. Wills, 2a Park Road, Cheriton and was built by Maltby's of Sandgate.

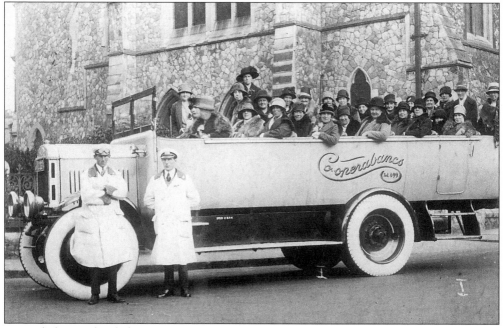

A coach for another ladies' outing parked outside the Congregational church, Tontine Street, *c.* 1925. This Co-operabancs charabanc is one of a fleet of seven Dennis coaches bought in 1921 with large pneumatic tyres. The full name of the company was Co-operative Transport Society Ltd, which was taken over by East Kent in 1928.

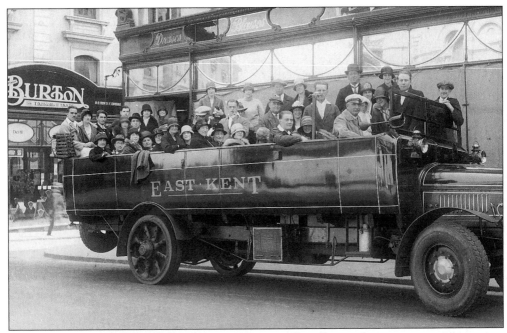

All set for another summer outing in a comfortable charabanc supplied by East Kent. The bus has a curious combination of large pneumatic tyres on the front, but solid rubber tyres and heavy gun-carriage style wheels on the back. It is parked outside the former Plummer Roddis department store in Rendezvous Street in around 1924.

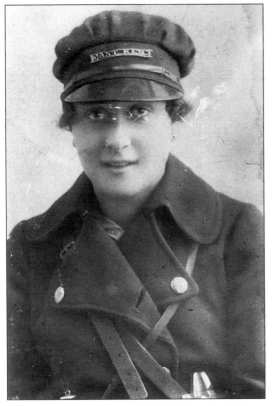

One of Folkestone's East Kent 'clippies', Ethel Moat, who was born in 1902. The photograph was taken in 1920.

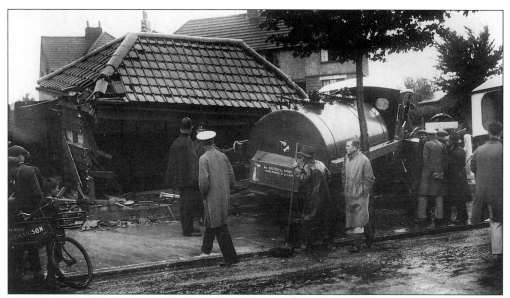

An accident involving a petrol tanker lorry owned by the National Benzole Company, which demolished the bus shelter at Wood Avenue, injuring three people sheltering from heavy rain on Wednesday 19 August 1931. Miss Muir, of Church Road, Wimbledon was badly injured – both her legs were broken. Another casualty with a leg injury and shock was John Thomas Gregory, of the 25th Squadron RAF at Hawkinge; Grace Hernden, of Athelstan Road, was detained in hospital suffering from shock and bruising.

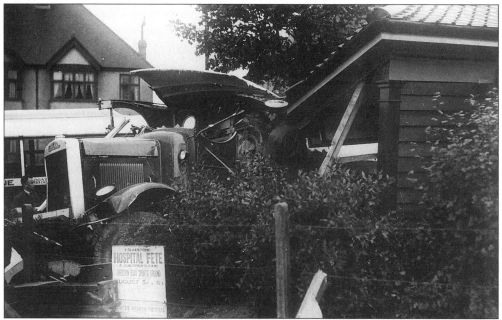

The Leyland tanker driver W.R. Simmonds of Stour Road, Canterbury and his companion both had a remarkable escape from serious injury, especially since the driver's cabin was completely wrenched off by the force of the impact. It was fortunate that there was no spillage of fuel or an explosion because the tanker was carrying 1,000 gallons of spirit when its brakes failed as it descended Canterbury Road.

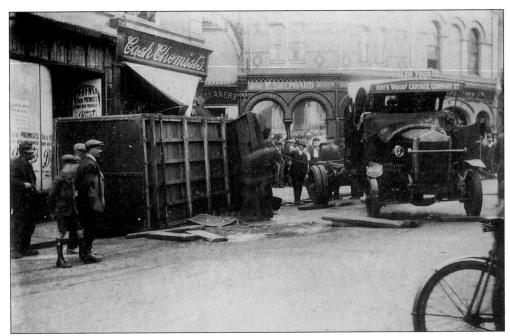

An accident involving Hay's Wharf Cartage Company's lorry in Rendezvous Street, 24 September 1923. The five-ton lorry from London was conveying meat for the Swift Beef Company and when it was in Sandgate Road it lost control. On turning into Rendezvous Street it ran against the kerb and overturned against the premises of Boots the chemists, whose shop front was shattered. The driver, Mr W.G. Clark of 20 Nealdon Street, Stockwell, was thrown to the ground, but fortunately his injuries were not serious.

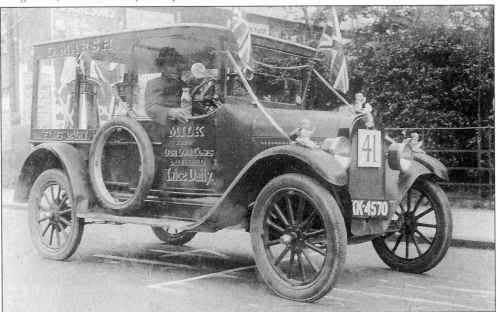

A Folkestone carnival float, early 1930s. The vehicle belonged to the Marsh Brothers, proprietors of Elms Dairy, 142a Canterbury Road. They claimed all the milk comes from their own farms.

A taxi-cab involved in an accident, Cheriton Road, May 1914. The taxi-cab careered across the road, mounting the pavement, colliding with a lamp-post and cannoning into a tree. The driver, Charles Thomas Shrubsole, and his two passengers were unhurt. The cause was said to be a fault with the steering gear.

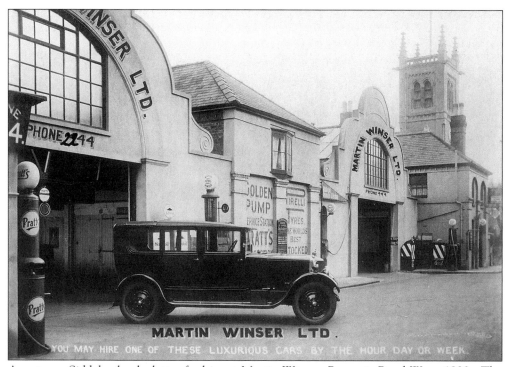

Armstrong Siddeley landaulettes for hire at Martin Winser, Bouverie Road West, 1930s. The rates were: minimum fare (2 miles) 1s 6d, thereafter 9d per mile; shopping (limit 5 miles) 5s per hour.

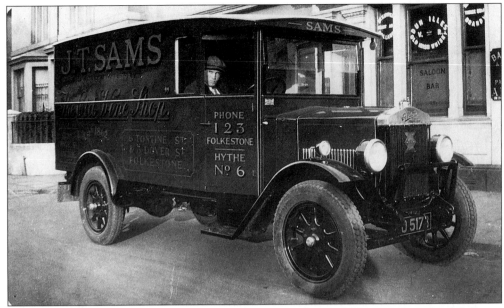

The delivery vehicle of J.T. Sams, wine and spirit merchants, 6 Tontine Street and 3 Dover Street, *c.* 1928. The business started between 1887 and 1891 and closed in 1967.

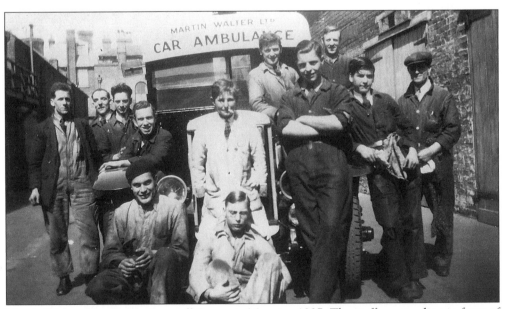

Martin Walters' service station staff, Bouverie Mews, *c.* 1937. The staff are standing in front of Martin Walters' Car Ambulance. Standing second from the left is George Hopper and second from the left, sitting, is Norman Banfield.

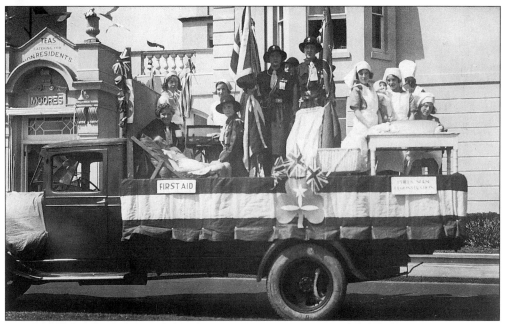

A carnival float parked outside Moores Hotel, The Leas. This is one of the floats which took part in the Jubilee celebrations for King George V and Queen Mary, 6 May 1935.

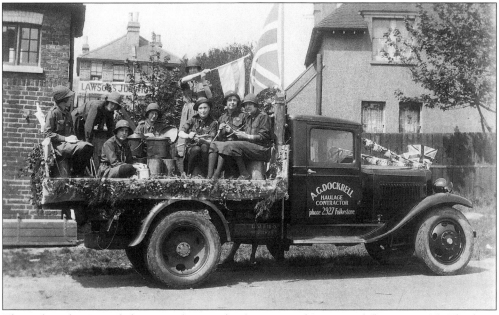

The girl guides around the camp fire are the feature on this carnival float, c. 1935. The lorry belongs to Alfred George Dockrell, a haulage contractor of 2 Thanet Gardens. Mr Dockrell was in business from 1926 to 1946, when the business was taken over by W. Reeves. The vehicle is a six-cylinder Bedford tipper lorry, built in 1932.

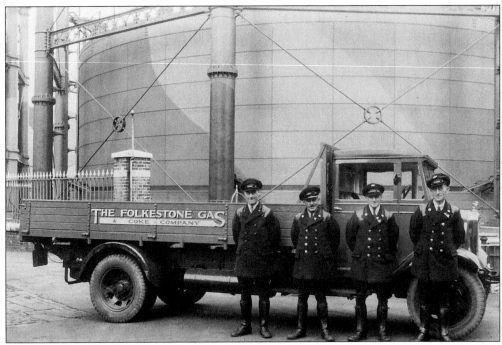

The Folkestone Gas and Coke Company's delivery men, 1940s. These men delivered coke; they are, from left right: Jack 'Darky' Trott, -?-, John Wild, -?-.

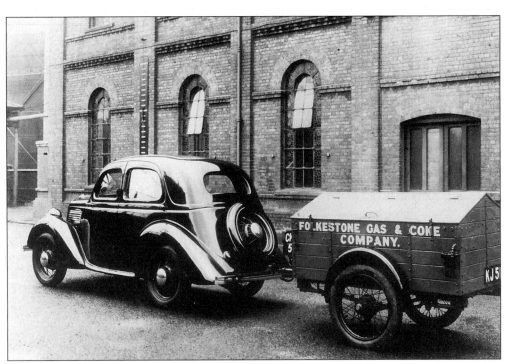

The Folkestone Gas and Coke Company's car and trailer, 1940s. The combination was used by the gas fitters – note the pipe vice on the back corner of the trailer.

Six

More Glimpses of Bygone Folkestone

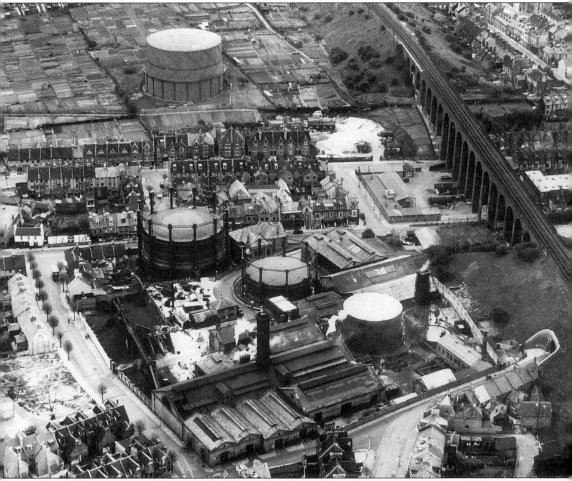

Folkestone Gas Works from the junction of Guildhall Street with Ship Street, May 1949. The first gas supply was provided in Folkestone in 1842, from a small plant on the beach on the site now occupied by a coach park. The gas works moved to this site in 1867 where it produced gas until 1960, after which it was piped from Dover.

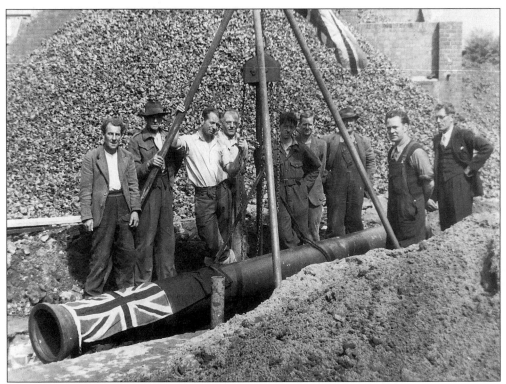

Folkestone Gas Works, May 1952. The gas employees are laying a twelve-inch diameter high-pressure trunk main from Dover Gasworks. They are from left to right: Francis O'Toole, J. Mulcany, Claude Devereese, Alfred Finch, Pat Boone, Fred Root, Bob Ellender, Arthur Punnet (blacksmith) and Reg Henderson.

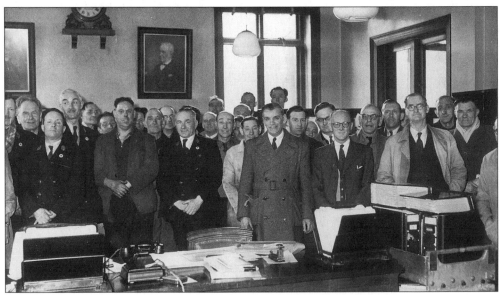

Employees at the retirement of Mr E.F. Smallbone, Engineer Manager of the Folkestone Undertaking, South Eastern Gas Board. It was held in the main offices at Foord Road.

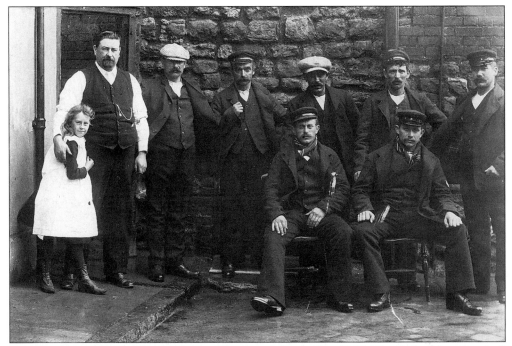

The survivors of the tug-boat *Sydney* of London, 1 September 1908. The *Sydney* foundered off Dungeness and the crew are seen here in Radnor Street, by the side of the Packet Boat Inn, with the landlord and his daughter.

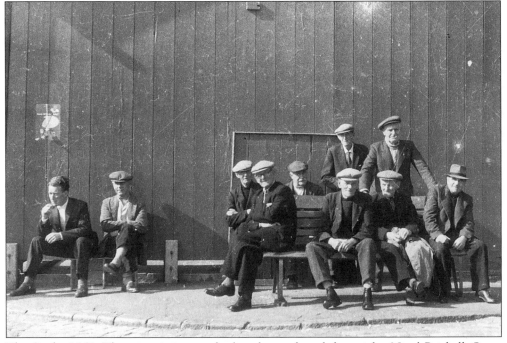

The Stade, 1961. The men sitting on the bench are, from left to right: Nigel Brickell, Steve 'Reddun' Fagg, 'Dusty' Miller, and George Taylor. Those behind are, from left to right: Fred 'Ussy' Pegden, Bill Whittingstall Snr, Bob Bliss Snr and Tommy Lee.

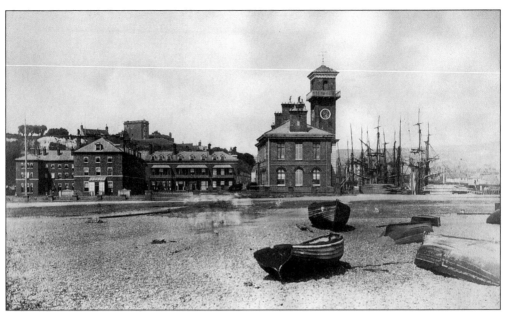

The Inner Harbour, Pavilion Hotel and Harbour Company's offices, 1882. A maze of masts can be seen at the Inner Harbour, which belong to the ships unloading timber. The Harbour Company offices were pulled down in 1899 to extend the Pavilion Hotel.

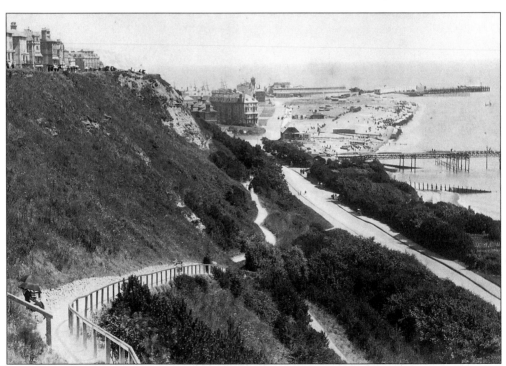

The Leas, Lower Sandgate Road, Victoria Pier, Marine Terrace, the beach and the Harbour, 1887. It is interesting to note that the Victoria Pier is just being built and that the decking boards are being laid. Walter Fagg's patent bathing machine is also being erected.

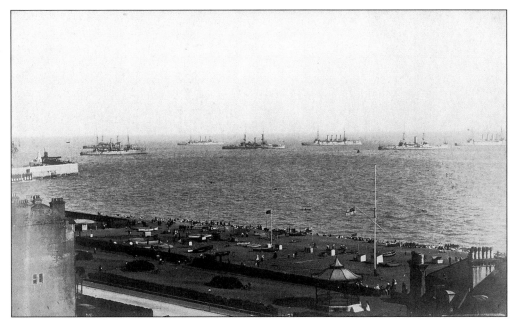

Some of the British naval fleet off Folkestone, 1905. These ships are part of the reserve squadron consisting of three battleships and six cruisers. The two ships with the four funnels are the *Terrible* and the *Powerful*.

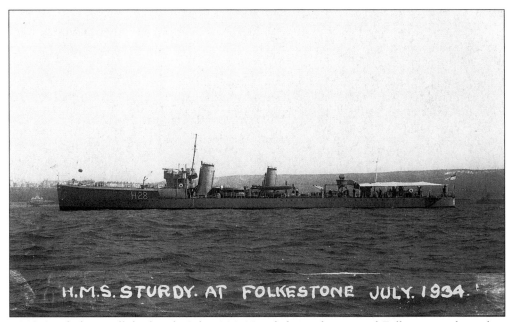

H.M.S. STURDY. AT FOLKESTONE JULY. 1934.

HMS *Sturdy* lying off the beach, July 1934. Naval ships often visited Folkestone, where they were usually open to the public; the pleasure boats ferried people to and fro.

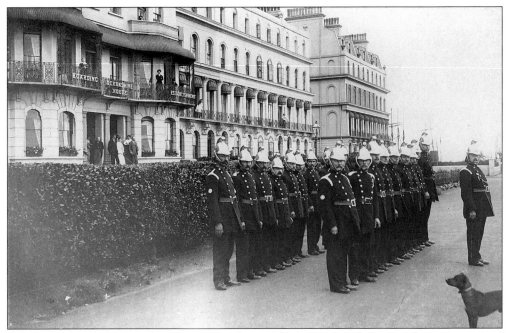

Folkestone Fire Brigade at the Marine Parade, *c*. 1920. Note their helmets, which are made of brass.

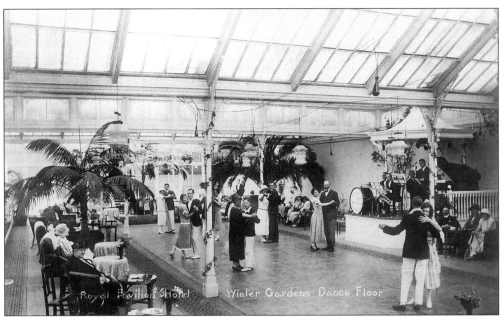

Dancing in the Royal Pavilion Hotel, Winter Gardens, 1920s.

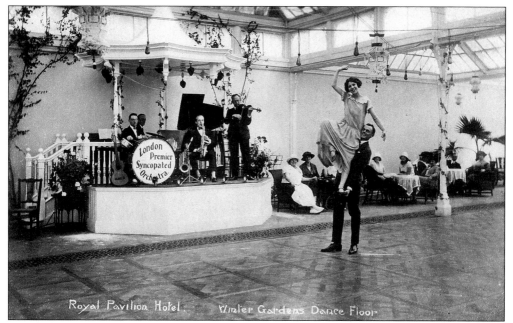

Dancing to the London Premier Syncopated Orchestra in the Royal Pavilion Hotel, Winter Gardens, 1920s.

The Leas staff, 1907. This group of uniformed men collected the money for deckchairs – some of them have 'collector' written on their hats.

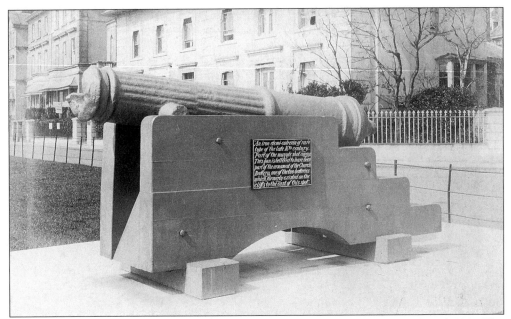

This gun, situated on the Leas, was removed to build the War Memorial in 1922. The inscription reads: 'An iron demi-cutrerin of rare type of the late sixteenth century. Part of the muzzle shot away. This gun is believed to have been part of the armament of the Church Battery, one of the two batteries which formerly existed on the cliffs to the East of this spot.'

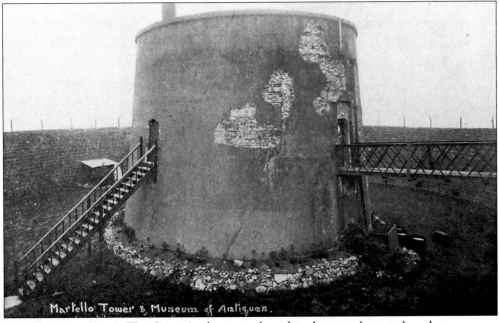

Martello Tower No. 4, West Leas. At the time when this photograph was taken the tower was being used as a museum for antiques. The steps, bridge and wall have long since gone.

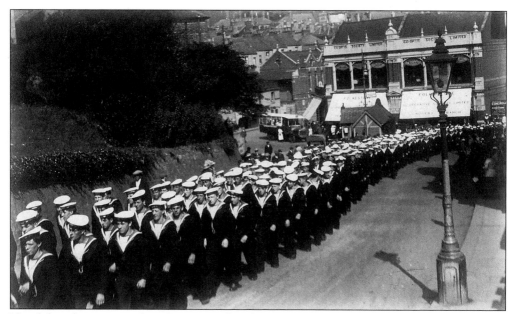

Naval detachments march up Dover Road in the summer of 1919. The sailors are taking part in a Peace Parade to celebrate the end of the First World War.

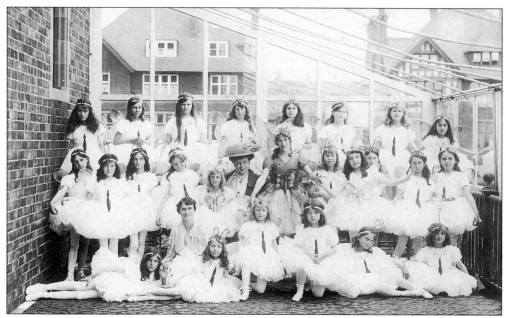

This is Miss Bridget Kier's troupe of ballet dancers, 'Roses and Butterflies', 21 July 1917.

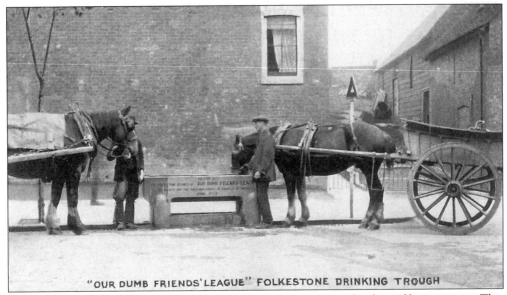

"OUR DUMB FRIENDS' LEAGUE" FOLKESTONE DRINKING TROUGH

One of the many horse-troughs which were around the town in the days of horse-power. This one was at the bottom of Black Bull Road. The inscription reads: 'Erected by The Folkestone branch of "Our Dumb Friends League" to society for the encouragement of goodwill to animals'.

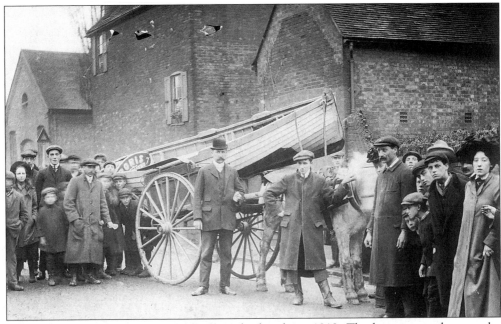

The rowing boat *Doris* on its way back to the beach, *c.* 1912. The boat is seen here at the bottom of Black Bull Road. The owner has just overhauled her and she is on her way back to the beach. Boats like this one were for hire, with or without a boatman.

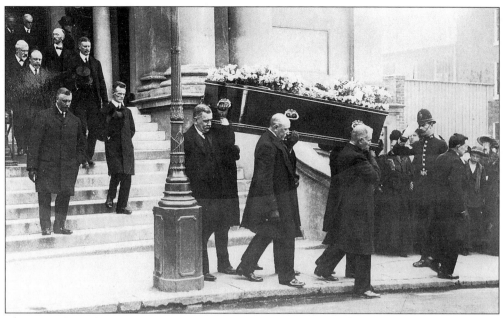

The funeral of Alderman Vaughan, May 1914. The coffin and mourners are seen here leaving the Baptist church in Rendezvous Street on their way to the cemetery.

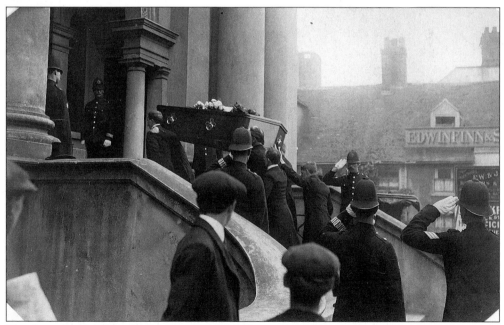

The funeral of Mr Marsh, draper, of Tontine Street, 1913. The coffin is being carried into the Baptist church, Rendezvous Street.

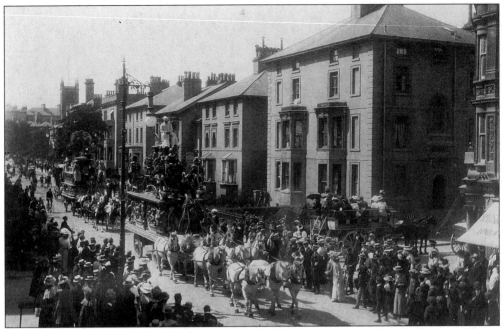

George Sanger's Circus procession and Asiatic Warriors (dressed in national costume) in Sandgate Road, August 1901. After touring the town the street cavalcade went to the football ground where they performed for two days.

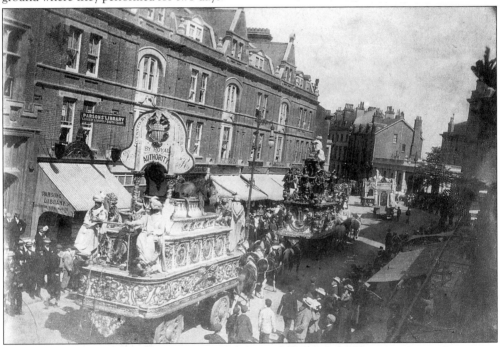

Mr Sanger presented his latest novelty show to the inhabitants of Folkestone. It was the Asiatic Warriors, dressed in full national costume; these real Chinese Boxers actually took part in the siege of the British Legation in Peking. Furthermore, Mr McFarlane, of Folkestone Football Club, competed against Sanger's centre-forward elephant for a massive cup.

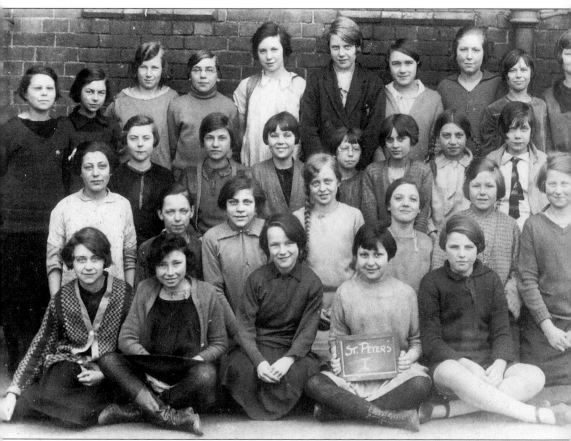

St Peter's School group, c. 1926. From left to right, front row: -?-, Lilly Hall, Gladys Marshall, Linda Watson and Dolly Dickinson. Second row: Edie Frodsham, Maggie Longhurst, Lou Watson, Renie Boulter, Amie Cook, Nellie Cornish and Nellie Avery. Third row: Queenie Miller, Ethel Allen, Rose Cornish, Ivy Stockley, Alice Fidge, Ruth Standing and Elsie Marsh. Back row: Molly Punnett, Lilly Farrer, Emma Hall, Edie Sawyer, Alice Bush, Alice Fagg, Emily Hall, Ivy Sharp Violet Smith and Betty Port.

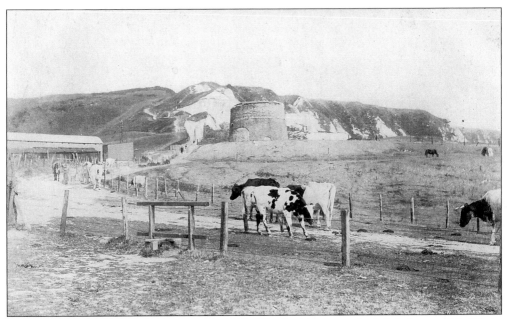

The Warren and Martello Tower No. 1, 1910. The buildings on the left belong to Mr Edwin Burbidge, a dairyman and farmer. These were the days when one did not need to go far to get out of the town: Wear Bay Road had not been extended beyond Wear Bay Crescent.

Park Farm and the Brick Fields, 1906. Development of Park Farm did not start until around 1950.